Painting Portraits

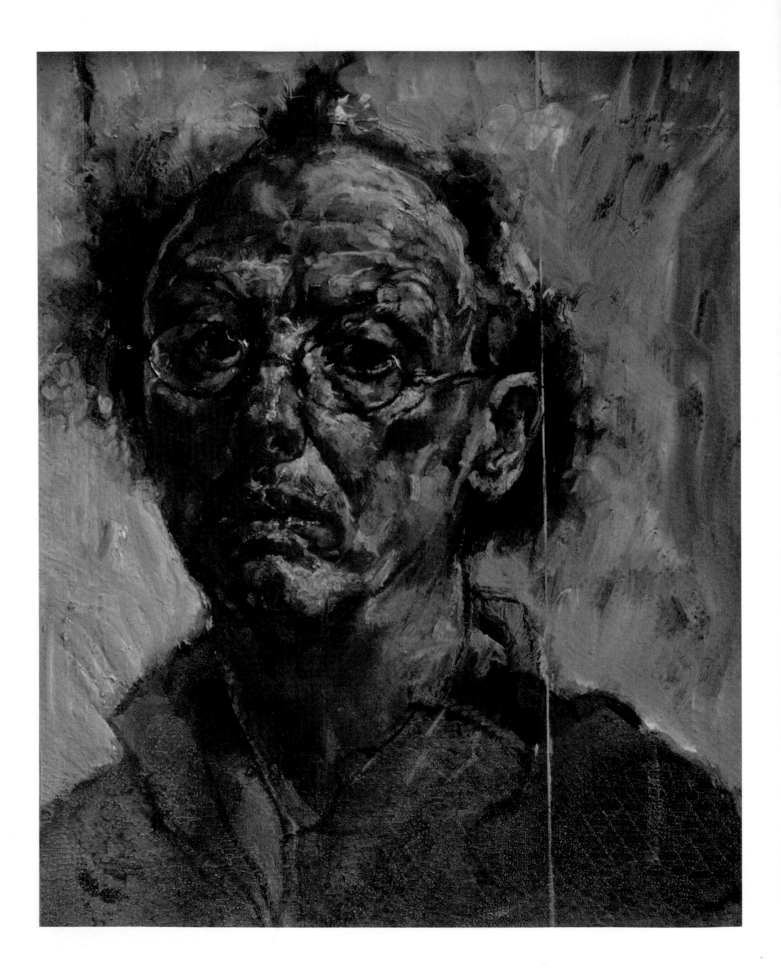

Painting Portraits

Anthony Connolly

THE CROWOOD PRESS

First published in 2011 by
The Crowood Press Ltd
Ramsbury, Marlborough
Wiltshire SN8 2HR

www.crowood.com

This impression 2013

British Library Cataloguing-in-Publication Data
A catalogue record for this book is available from the British Library.

ISBN 978 1 84797 264 4

For Coleman and Bridget

Typeset by Sharon Kemmett, Isis Design
Printed and bound in India by Replika Press Pvt. Ltd.

CONTENTS

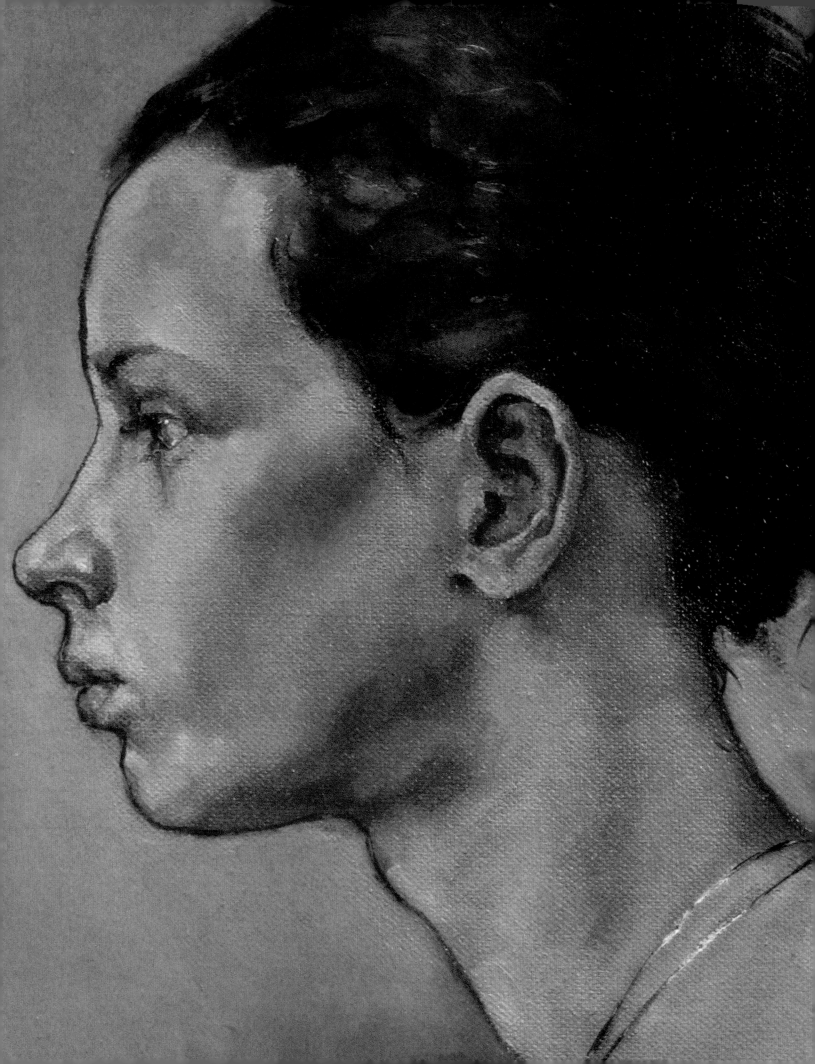

INTRODUCTION

'It's not as if an instinct which lies in the race of men from way before Sassetta and Giotto has run its course. It won't. Don't listen to the fools who say that pictures of people can be of no consequence ...'

R.B. Kitaj

What Is Portraiture?

Our ideas about portraiture are probably rooted in a period that begins in the late middle ages and continues until the end of the seventeenth century. This period saw the revival of the individualized, *au vif*, portrayal of the powerful, influential and successful. The seventeenth century was the era of Rembrandt, Peter Paul Rubens and Diego Velázquez, and of the most exquisite painting from life. By the nineteenth century, the portrait is very often, although of course not always, a solid signal of status. Like much Victoriana, such paintings are usually highly crafted, over-engineered even. They can be so well-finished that sometimes one feels the paint has been polished up to produce pure alabaster and the sitter, in consequence, is petrified. In the twentieth century, Modernism set off in pursuit of the interior. Inner truths were sought, unlikely and unfamiliar faces, gathered in from Africa or found in doodles, acquired resonance. 'Unlikeness' became valued and portraiture, which really exists only to represent likeness, waned as a result.

That we should still be making and cherishing painted portraits, then, is something of a conundrum. The annual BP Portrait Award exhibition, hosted by the National Portrait Gallery in London, is one of the highlights of the popular cultural year. The annual exhibition of the Royal Society of Portrait Painters at the Mall Galleries, also in London, draws thousands of visitors.

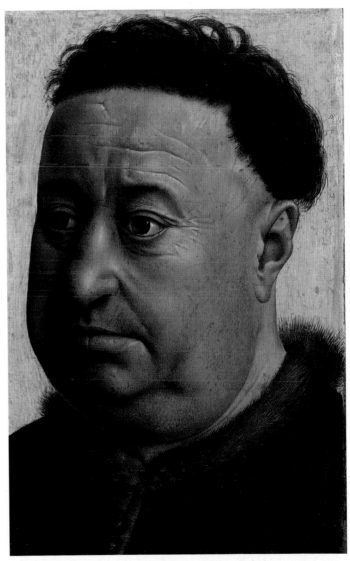

Robert Campin, Portrait of a Fat Man (Robert de Masmines), 1425–30.

LEFT: *Magdalen*, 2003 (oil on canvas).

These shows may not attract quite the same glare of media attention as the Turner Prize, but my impression is that the actual footfall is probably greater. Portrait painting doesn't just survive; it thrives. It persists through all the stuttering complexity of change, through the spurts of action and reaction, imitation and contradiction, through all the layering of new and newer technologies. Through turmoil and fashion, people keep making, and sitting for, painted portraits.

In Europe, recognizably individual portraits date back to the early fifteenth century (although they were possibly not described as portraits until the sixteenth century). Robert Campin's Portrait of a Fat Man (Robert de Masmines), 1425–30, is an example of the closely observed likeness that still characterizes much contemporary portraiture. There is no attempt to

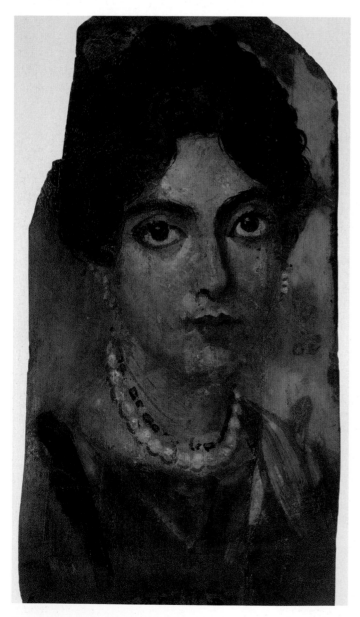

Fayum mummy portrait, *Woman With a Double Strand of Pearls.*

idealize; Robert de Masmines has a fleshy, unbecoming gaze.

The early fifteenth century seems to have been an historical period during which an intensity of looking and recording became necessary or desirable. Prior to this, only Roman portrait busts aspire to the same degree of reality. There are times, perhaps, when our individuality, our uniqueness, has to be set or recorded. It is unlikely, however, that the function of a painted portrait in fifteenth-century Flanders would be the same as the function of a painted likeness today. Beliefs, values, technologies, our understanding of what it is to be human, have all changed since 1430.

It is conceivable that a painted representation in the fifteenth and sixteenth centuries was used in the way a photograph might be used today, as a communication of appearance. In 1538 an English ambassador in Brussels arranged for Hans Holbein the Younger to paint Christina of Denmark. Henry VIII wanted to see the Duchess's likeness because he was thinking of marriage. She eventually married elsewhere, but Henry was much taken, it seems, with the sixteen-year-old depicted in Holbein's painting. Indeed, her likeness still captivates; the painting now hangs in the National Gallery in London. Nowadays, we have more immediate, technological means of communicating appearance, although similar transactions are probably just as risk-laden.

In 1956, the then leader of the Soviet Union, Nikita Khrushchev, attacked the 'cult of the individual' and specifically the cult of Stalin. Khrushchev argued that this cult 'brought about rude violation of Party democracy, sterile administration, deviations of all sorts, cover-ups of shortcomings, and vanishings of reality'. More recently, the cult of the individual has had other, more venal, manifestations and cult status has become rather more easy to acquire. I have certainly heard a thirteen-year-old refer to an acquaintance as a 'legend'. The prospect of becoming famous has elbowed its way up in the collective psyche from being a consequence of achievement to being a career aspiration in itself, fuelled by 'reality television'. 'Celebrity' even has its own professional hierarchy – 'C listers' and 'B listers', all hoping one day to be 'A listers'. Fame has been democratized, as was foretold by the shaman, Andy Warhol. It has to be self-evident that we have all scratched away at reality a little by becoming complicit in this cult of the individual. The Co-operative Funeral Service recently conducted a survey of music played at funerals. Frank Sinatra's rendering of 'My Way' was the song most frequently requested to mark a person's passing. This might be trivializing the point, but portraiture must owe something to our continuing, our rampant, fascination with the individual; with ourselves as celebrities.

Nevertheless, since the Renaissance the portrait has undoubtedly become something of a mark of status, a fitting tribute to a remarkable individual. The great and the good, the celebrated and the infamous, have all gone under the brush. Ironically,

the very great are rarely the subject of very great portraits. The subjects of those truly unforgettable paintings, such as the portrait of Baldassare Castiglione by Raphael, are often rather minor historical figures. Even those who were kings, like Philip IV of Spain, are arguably more easily remembered today because they were painted by such painters as Velázquez. Another example, Madame Moitessier, may well have done it her way, but we think of her now because her husband, a wealthy banker, had the means and judgment to commission Ingres to paint her portrait. When we call to mind the painting of Lord Ribblesdale, we remember John Singer Sargent, just as in the crematorium it is difficult not to think of Frank Sinatra.

If, however, we want to have a larger appreciation of the relevance of the painted portrait today, we might have to look beyond notions of the individual, beyond reality television or the Renaissance for a precedent. The earliest painted portraits to survive in any number are the so-called Fayum paintings. Although the practice of interring funerary masks with mummies dates much further back, the Fayum paintings were made during the first and second century AD and were found in necropoles in Egypt at the end of the nineteenth century. These paintings, just like Holbein's painting of Christina of Denmark, were functional. The art critic and novelist John Berger assigns two distinct functions to these haunting paintings. The first is as a memento for the family and friends of the deceased during the period of embalming, which could last seventy days. The second function Berger likens to a passport photograph, preserving identity during the journey to the Kingdom of Osiris. These paintings were ultimately not for popular consumption, as they were buried with the corpse. They represent an attempt to preserve tangibly both the likeness and the soul. I can't think that the two terms, likeness and soul, are synonymous, but the relationship is established and complex.

These faces are not detailed records in the way that the Robert Campin portrait seems to be, but they are often so direct and vivid that one is entirely persuaded of the presence, the reality of the person. I think contemporary portrait painting has much to do with this association of likeness and soul. We might shift to a different vocabulary, preferring perhaps 'presence' or 'essence' to the word 'soul', but the association is there. Por-

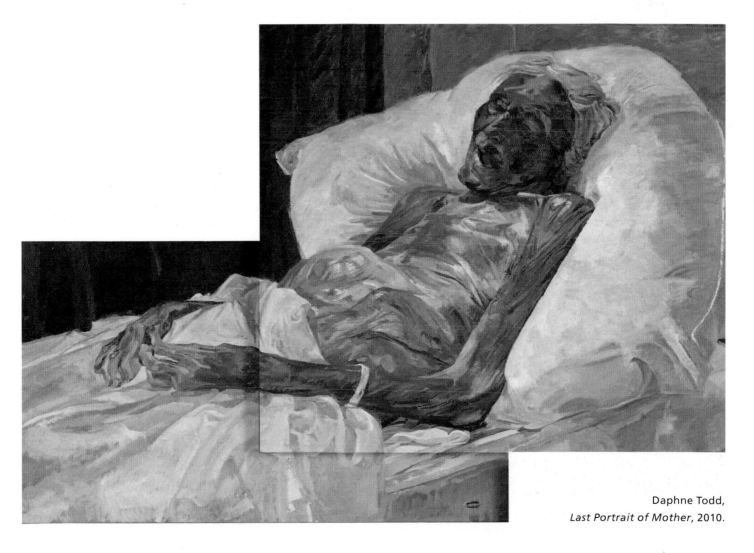

Daphne Todd,
Last Portrait of Mother, 2010.

traiture might today still be perceived as some measure of a person's importance in the world, a token of their celebrity, but contemporary portrait painting is very often more layered; like the Fayum pictures, painted portraits today typically depict private individuals, not pharaohs or soap stars, but people who are precious to a relatively small number of intimates.

When I saw Daphne Todd's painting of her dead mother, I was astonished. We live remotely from death and coming upon such a tender and real representation in the National Portrait Gallery was shocking, wonderfully shocking. There was nothing remote there, nothing hidden or harsh. The bare torso seems bereft, a testament to the departed life, a delicate husk. We know this is a painting made from life, whereas we don't know whether the Fayum paintings were made posthumously or not. *Woman With a Double Strand of Pearls* is so seemingly alive, however, and *Last Portrait of Mother* so seemingly dead, that it seems both paintings delve into the same moment, splicing together now and then, death and life.

The painted portrait is not an anachronism, even though it is now so much easier to represent reliable and sometimes startling realities with a camera. The means to make extraordinary visual records have been mass-produced and made very affordable. We can all have the tools to make pictures with the detail and moment of an Ingres. These tools are, of course, managed more successfully by some than others. We are enjoying a technological endowment which gives every one of us the capability of producing extraordinarily vivid and precise images. With little or no apprenticeship we can become pictorial craftsmen with fabulous technical capabilities. Skill has become a commodity, a very affordable commodity, and possibly, as a consequence, has been devalued. This may be in part the reason why we still turn to the unique, hand-crafted portrait, because in its very form it remains a metaphor for the uniqueness of the individual depicted. It may be that when we move oil and pigment around on a piece of linen with the intention of making a likeness, we are still trying to do exactly what Rembrandt did, sliding paint into truth. Perhaps portrait painting is such a consistently human activity that both Robert Campin and Rembrandt would know exactly what we are about. It is certainly true that a well-painted likeness is special.

Art or Craft?

Portrait painting, then, is an enduring and popular art form. There is a contradictory mass of opinion, however, that would not regard portraiture as a valid concern of art. You are unlikely to find the gurus, the 'A listers', of contemporary art involving themselves with the making of portraits, except in a kind of sub-ironic way. In 2006, for instance, the Chapman brothers became portrait painters. They produced, apparently, a 'mind-boggling' fifteen portraits a day for five days. They set out their stall at the Frieze Art Fair in London and produced each portrait, from life, in about thirty minutes. The critic Sarah Kent, writing in *The Times*, illuminated the intention of the brothers: 'This is a demonstration of bravado, a flaunting of rapidly acquired skills to debunk the mystique of portraiture in particular, and oil painting in general'. The term 'portrait artist' here has to be an oxymoron. Portraiture is a form which is largely eschewed by our most highly valued makers of art. 'ART' has become a kind of Kitemark, jealously guarded by those who lay claim to its deeper or higher manifestations. The cachet 'ART' is hot property, high fashion, big business. Preserving the mystique of 'ART' requires that the mystique of portraiture be debunked. In this hierarchy of 'ART' portrait painting is best described as a craft.

I belong to a generation of artists (or craftsmen?) which was nurtured in the belief that craft need not underpin art or, more precisely, that craft was not an attribute of art. There were probably those who would have said that if an object was well made then for that reason alone it could not be art. Suspicion was aroused if one's work relied upon or displayed any excess of craft. Craft had very little to do with art and it might actually become a corrosive ingredient of the art one was trying to make. My teachers posed questions about the nature of art, for instance: 'What essentially is a work of art?'; 'What is the function of art?'; 'How does a piece of work become art?'; 'Is a painting automatically art?' In turn, obviously, we were encouraged to ask and explore similar questions. Does one actually need to do anything to an object to make art? Does one need to make anything, other than a choice, or an argument? These are all valuable and necessary questions.

Damien Hirst's *The Physical Impossibility of Death in the Mind of Someone Living* (his shark in formaldehyde, 1991) is typical of the kind of work such thinking and pedagogy produces. Comparisons have been made between the factory or studio practice of an artist like Hirst or Jeff Koons and the studios of some great seventeenth-century painters such as Rubens. I don't think the comparisons are sound, however, mainly because Rubens, like Hirst, was the resident genius and artist, but he was also the master craftsman. I very much doubt that he would have separated the two roles quite so easily as we seem inclined to do. This also seems to be a situation peculiar to the visual arts. In other disciplines, for example literature and music, technique, style and craft remain necessary and important constituents of the work. Now, I don't want to throw the shark out with the bath water but, enthralled though I am by much of the work produced during the latter half of the last century, I remain uneasy about this devaluation of craft.

Stephen Farthing discussed the changing value of craft in his excellent book, *An Intelligent Person's Guide to Modern Art*. He described a model of art teaching that was prevalent until the middle of the twentieth century. Students would be expected

to acquire craft skills through repetitive practice. This acquired fluency in their chosen craft would enable them to communicate effectively through that medium. The actual content of the work was of secondary importance. This was the model against which artists and teachers reacted, especially in the second half of the century. My formation through art school was on the crest of that reaction, but I have come to think that the distinction between art and craft is too facile. The foregrounding of art, or content or idea, is just too contrived to sustain my belief. I fully agree that visual art, like theatre, requires me to suspend my disbelief, but my imagination needs sustenance. Ideas in contemporary art, like jokes, don't keep very well.

I prefer, for instance, Marc Quinn's photographic portrait of Sir John Edward Sulston, to his 'portrait' of the same man, which consists of a sample of the sitter's DNA in agar jelly, mounted in stainless steel. The idea is intriguing but the idea can exist as easily on this page as in the object itself, and it does not haunt me in either manifestation.

Art, unlike the word craft, has become a term that is difficult to confine or define. Like the art historian E.H. Gombrich, I think it may have become a kind of fetish. In some senses one can only define such a term in reference to some larger narrative and I shy away from framing a limited understanding within any grand or gilt affair. Whenever portraiture is discussed, however, one almost invariably comes back to some notion of presence or soul. In the absence of a reliable definition of art I will, and not without some trepidation, suggest that portraiture may be a form or a craft in which presence or soul or art, by some definition, can persist.

MATERIALS

I have tried, as far as is possible, not to become unnecessarily distracted by the things I use to make pictures. I like to think that the means, the materials, are less important than perception and understanding. More or less permanent marks can be made on all kinds of surfaces and a likeness will emerge if the marks correspond with accurate observations. A portrait can be made by staining an old cotton shirt with a squashed dandelion or by applying black insulation tape to a white wall. It is really only important to make the right mark in the right place.

A fourth-rate journalist in a short story by Anton Chekhov distracts himself with the accoutrements of his craft. 'There is nothing casual, nothing ordinary on his writing table, down to the veriest trifle everything bears the stamp of a stern, deliberately planned programme.' He reassures himself that he is indeed a writer, an author, by surrounding himself with the materials of his trade. He might rise to the rank of third-rate journalist If he could only see through this mist of himself and his writer's things. Similarly, while it is important to find a way of making marks and applying colour that works, it would be a mistake to believe that good materials make good paintings.

This, however, is not to say that I am not fascinated by paint. I have not been immune to the lure of the alchemy of precious pigments and fragrant oils. I used to want to prepare my own grounds, mix my own paints, I even became interested in the manufacture of brushes, to the point of plucking hairs from the hide of a dead badger.

I still like browsing in art shops and I often buy a brush or a particular tube of paint 'just to see'. I like the stuff of painting and in some part a painter has to communicate or share this pleasure, but for a portrait painter the likeness remains the sine qua non. The business of a portrait painter is to fix a likeness in a way that might engage and endure. There are wonderful materials on the market with which to do this. I feel the real task is to pare away those materials that are not essential.

Palette

To know what is essential, I have to prioritize. Drawing has always been in the middle of the way I try to make pictures. Paintings, for me, always begin with drawing and really a likeness depends on it. I was introduced to drawing with paint, and particularly, Burnt Siena oil paint thinned with turpentine, by a teacher on my foundation course. It delighted me then and, if anything, delights me even more now. Drawings made in this way are already colourful. They provide a core. Drawing is a priority and so whatever materials I use I have to be able to draw with them. That is, the materials have to be able to hold the nuance and precision that a portrait requires.

I then looked at the work of the painters I most admire. I began by going back to Velázquez, courtesy of the painter Avigdor Arikha. As well as being a painter, Arikha was a distinguished art historian. The palette I chose to build out of my drawing is an approximation of Velázquez's palette as described by Arikha. I chose it because it is clearly sufficient, at least for Velázquez. Standing before his painting of Pope Innocent X, 'the whispers of the two lives traced upon the canvas – the painter's and the sitter's – will resound in one's heart.' Velázquez uses probably not more than seven or eight colours, including black and white.

I then went to Rembrandt. I don't know how he made his paintings but just by looking at them one can see the rivulets of thin paint running into the under-painting and then there will be a gash of opaque colour smeared across the top. On top of this again traces of thin liquid paint settle into the furrows made by the brush.

I added a further requirement that the few colours I intended to use should be classed as transparent or at least that they should glaze well. I quite often glaze over areas of paint and I want to preserve the under-painting, and, sometimes more importantly, the drawing. My priorities then are:

LEFT: **Paintbox.**

- drawing
- as few colours as possible
- paint, which can be both opaque and transparent.

Because my choice of colours contains a preponderance of earth colours, I fancy that there is something ordinary and deep there on my palette. They are permanent and rich. Earth pigments are some of the oldest pigments known to man and were used in prehistoric cave paintings.

- **Burnt Sienna** - I find this the richest colour in my palette; there seem to be so many other colours within it. I do find that different manufacturers make quite different Burnt Sienna, and so it is worth comparing to find something that suits your needs. Burnt Sienna is made by burning raw sienna, which is a clay rich in ferric oxide deposits. I use a brand that is actually produced synthetically. It is classed as a transparent colour.

- **Yellow Ochre** - Yellow ochre is made from natural iron oxide and is classified as semi-transparent.

- **Raw Umber** - Raw Umber is made from natural iron oxide and is classified as semi-transparent.

- **Cadmium Red** - Cadmium Red is made from cadmium sulphoselenide and is classified as opaque. It nevertheless glazes well.

- **French Ultramarine Blue** - This is very similar to the blue made from Lapis Lazuli. It is classified as transparent.

- **Flake White** - This opaque white is made from lead carbonate and zinc oxide. I use this whenever I need a white, on its own or to mix with other colours.

- **Titanium White** - This white is made from titanium dioxide and zinc oxide. It is classified as opaque. It is a very bright white that I use occasionally, especially for highlights.

- **Ivory Black** - Also known as bone black, this is made from charred bones. It is classified as semi-opaque.

Brushes

I use just one or two filberts, a fine-pointed round brush, and a flat half-inch brush for laying glazes down. I generally find that synthetic brushes give more control and last well.

Grounds

I paint on a variety of grounds.

- **Gessoed MDF** - I like to use the commercial MDF available from builder's merchants. Usually I opt for a 6mm thickness, which is fairly rigid and still quite light to handle. The gesso I use is produced commercially and available from any art materials shop.

- **Primed Linen** - Again, I usually buy this ready-prepared with an acrylic primer. I stretch my own canvases, but also buy ready stretched.

- **Paper** - This is usually pasted on to MDF and coated with gelatine. I use a variety of papers but generally choose a reasonably good quality cotton rag paper. I paste this onto MDF with commercial cold water wallpaper paste. When it is dry, I coat with some gelatine to seal the paper a little so that the oil paint doesn't soak straight through the paper. I use culinary gelatine, the kind used to make jellies and aspics, and follow the manufacturer's instructions. I apply the gelatine as it is cooling, but obviously before it sets.

Medium

I mix stand oil (linseed oil) with pure turpentine, in equal proportions. Occasionally when glazing I add literally a drop of damar varnish to this mix.

This painting illustrates quite well the colour and translucence that can be achieved with a quite limited palette. The hair has been glazed first with Raw Umber, then with Ultramarine Blue. Underneath and between these glazes, the hair and head have been 'drawn' with greys, blues and browns. The lights have then been laid in to the still wet glaze. Once dry small areas, such as the shadows behind the ear, have again been glazed.

This practice of glazing with translucent paint and then applying solid colour is not easy to describe as a sequential process. The under-drawing, probably in Umber and Sienna, might be allowed to dry and then a series of glazes could be laid on the surface to 'colour' the painting and the highlights would be applied last of all. This seems to be a clear and structured approach to making a painting. Painting, however, does seem to occur more felicitously when such structures are neglected. The painting itself can dictate when to glaze or when to apply solid colour. It may well be that highlights, which sensibly might be among the last marks to be made, are themselves glazed over or painted out so that another interpretation or observation can be added into the surface.

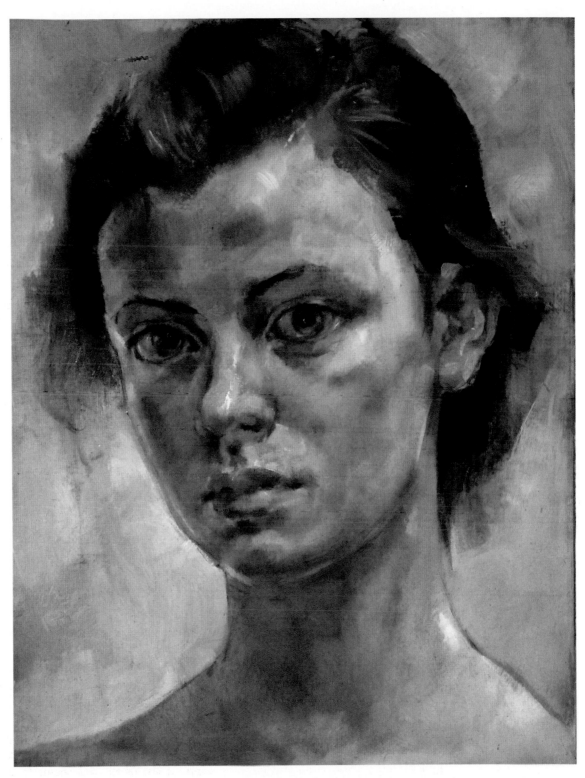

HMC, 2003.

Some of the light and softness in this painting is as much an attribute of the paint as of the image. One could isolate an area on the surface, abstract it from the painting, and the pale blues, pinks and the treatment of the paint itself would still communicate some sense of delicacy and fragility. That is to say the fragility of the head is communicated through the layering of opaque and translucent paints. That process of layering is itself fragile because there is no specific sequence; it can't be repeated. Some of the blues on the cheek will be glazed, others solid paint. Similarly, the reds on the cheekbones have been glazed in and then painted over. The light beneath the chin has been softened by some thin Burnt Sienna. All these subtle adjustments have been made in response to the model and not dictated by a particular ordered approach to applying paint.

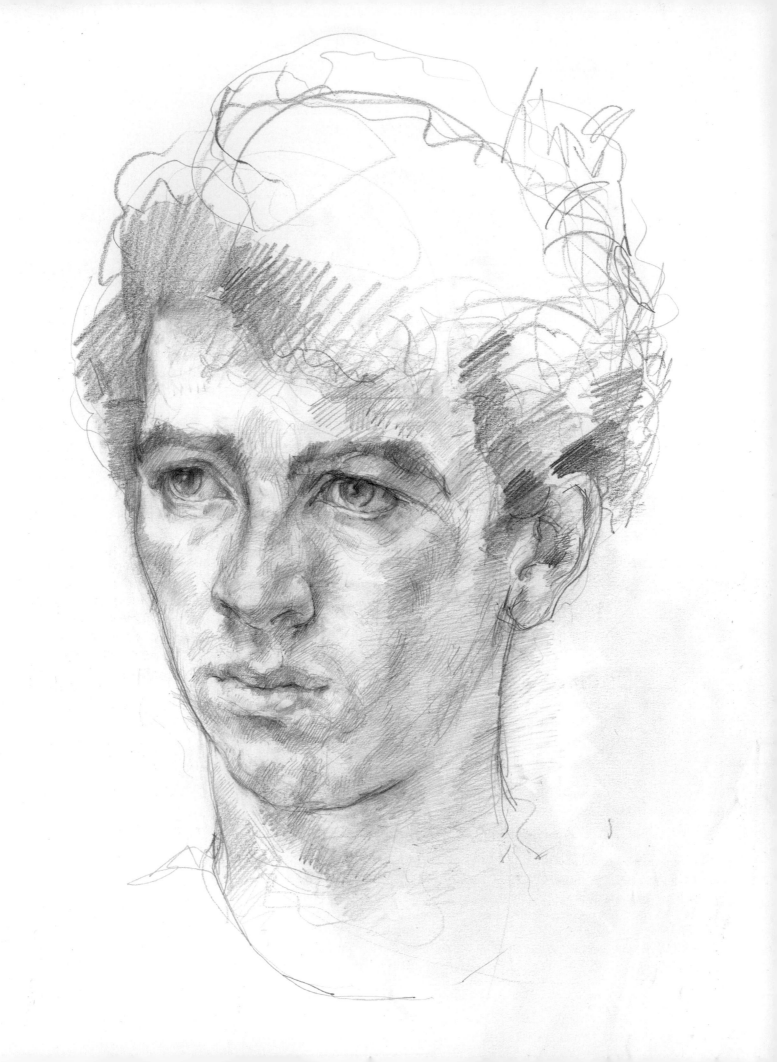

DRAWING TO PAINT

If you wish to obtain quicker perceptions of the beauty of the natural world, and to preserve something like the true image of beautiful things that pass away, ... if you also wish to understand the minds of the great painters, ... then I can help you. Only you must understand, first of all, that these powers, which are noble and desirable, cannot be got without work.

John Ruskin, The Elements of Drawing

Drawing is a compulsive, primal act. There is just something innately human about the impulse to draw. It is the most immediate, direct visual medium. There need be very few technical considerations. Something to draw with and something to draw on; that's all. If the drawing is conceived as an inquiry into its own nature, as an abstract investigation, one doesn't even need anything to draw 'from'. The portraitist, however, does need that third ingredient, a subject. In drawing from life, the portraitist is not only tracing his or her mark onto the tangible world, he or she is also attempting to record a perception of another human being, in such a way as to recall, to re-present, that unique individual to others. This is very particular. An ideal head, an imagined head, even a remembered head, will scarcely make a portrait. A portrait is an intimate investigation – to be convincing it has to hold that authority which is acquired by repeated, precise recording of detail upon detail.

Research has indicated that a professional artist, when drawing from life, will generate an unusual and intense pattern of eye movements. Repeated 'fixations' (a term used to describe the moment during which the eye fixes on a single visual detail) on a specific part of the sitter's head result in quite small and relatively few marks on paper. A drawing is the result of an accumulation of these close, careful observations. In the case of one particular artist, Humphrey Ocean, it was recorded that a 'fixation', lasting on average one second, would cause the artist to produce about 1.5cm of line. Drawing longer lines frequently necessitated multiple observations or 'fixations'. The drawing was seen to grow through an accretion of detail, rather than holistically. It was also observed that the artist would rehearse lines while repeatedly 'fixing' on the model before committing to a mark.

Likeness resides in the particular, not the typical. In learning how to draw a convincing nose or a realistic mouth you will acquire the skill to construct the typical. To make a portrait, it is necessary to learn to observe the particular as it pertains to each individual. Formulas regarding the structure and proportions of the face are not ultimately useful if you are really seeking to see the person in front of you, unless, of course, you can measure all the ways in which the sitter's physiognomy errs from the ideal. Consequently, drawing from life requires the draughtsman to begin again every time, as if knowing nothing, like a complete novice. Perhaps this is one of the reasons why Ron Kitaj remarked, 'It is, to my way of thinking and in my own experience, the most difficult thing to do really well in the whole art.' The sitter moves, the relationships between the features change constantly. The draughtsman's ability to record wavers. There are so many variables. It is nevertheless in the accumulation of corrections, in the drawing out of the likeness, in stubbornness, that the artist gives presence to his or her work.

In his poem 'Elogio de la Sombra' (translated as 'In Praise of Darkness'), Jorge Luis Borges describes his loss of sight:

> Democritus of Abdera plucked out his eyes
> in order to think;
> Time has been my Democritus.
> This penumbra is slow and does not pain me;
> it flows down a gentle slope,
> resembling eternity.

LEFT: *Inigo*, 2009.

It seems that in the darkness he has acquired a kind of freedom to leave behind distraction and everything that intrudes:

> I reach my centre
> my algebra and my key,
> my mirror.
> Soon I will know who I am.

The draughtsman has to hope for, dream of, a similar clarity. Faced with a completely blank sheet of paper and his or her own inadequacies, the portraitist has to give some shape to the light, to introduce some darkness, enough to draw from the paper and from the sitter something of the visible, and hopefully something of the invisible. Although the exercise is primarily visual, a human presence is, obviously, far more than a visual phenomenon. A drawing is a recording of what is seen, but also, to some degree, of what is known. With acuity and persistence it is possible to gather just enough information. Acquiring too much or incorrect information is the acquisition of confusion. The drawing is like an organism that selects and feeds off the visual stimulus. It is a collection of small, precise decisions.

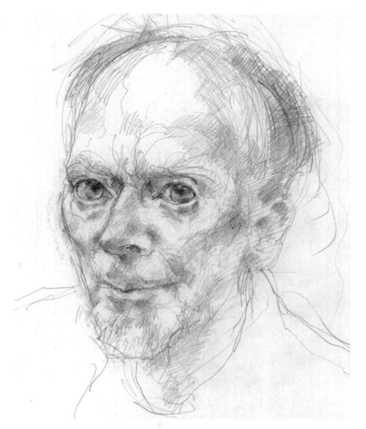

DT, 2010

When standing before a drawing by Holbein it is possible to imagine that the ghost of the sitter has been wafted onto the paper; the impression is so precise that it seems still to contain breath. The stillness is perceived as a temporary condition, a moment given to the viewer. The means used to achieve this are so slight that it could be correctly described as elegant in the mathematical sense; surprisingly simple and completely effective. These are the qualities of fine drawing.

Drawing is fundamental to making a portrait. It is, in the words of Pliny, 'the supreme refinement of painting'. Painting is simply full of drawing, which might be well done or otherwise. Drawing may be perceived as a stage in a progress toward some more final, finished goal, such as a painting. It might also be that drawing is simply a more elegant solution. It is certainly necessary to a painted portrait. The Florentines were acclaimed for their use of line and the Venetians for their mastery of colour. This is misleading to some extent because it is not really possible to extricate one from the other. A similar divide existed between the 'Poussinistes' and the 'Rubéniens', in an argument that started in the French Academy in the seventeenth century. Ironically, Poussin tended not to draw from life, whereas Rubens did it all the time. Colour, certainly for the portraitist, simply doesn't function without line.

There follows, as a kind of prelude and preparation to the more ambitious task of painting a portrait, a series of portrait drawings. All these drawings grew from the very specific observation of each sitter's right eye. I don't know if this habit of beginning with the eye is taught or if it instinctive; it is certainly not uncommon.

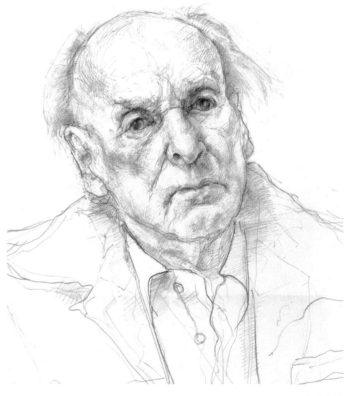

CB, 2010

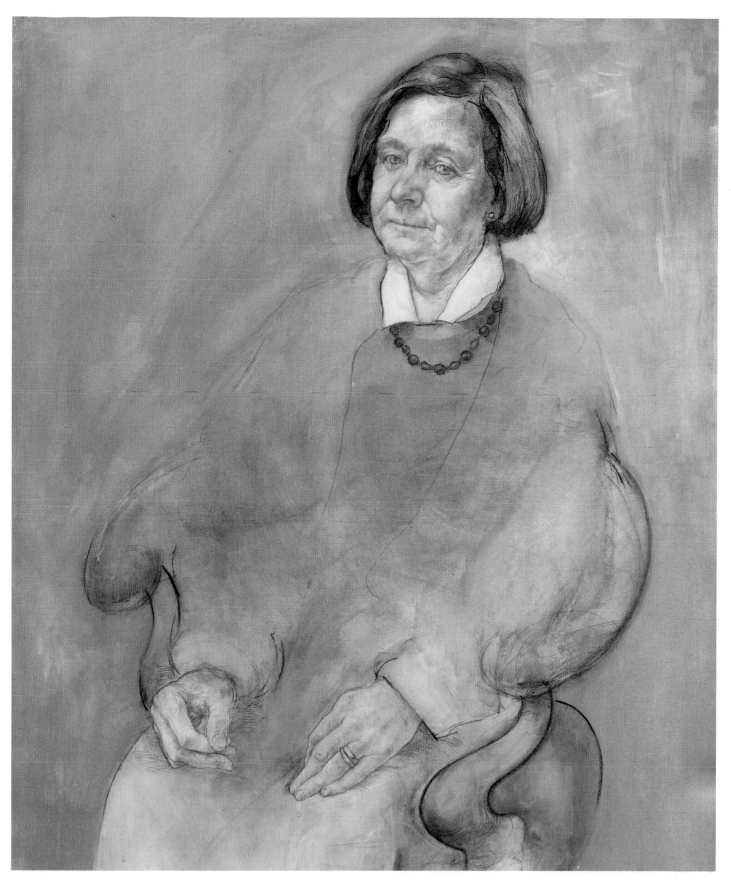

AVD, 2004.

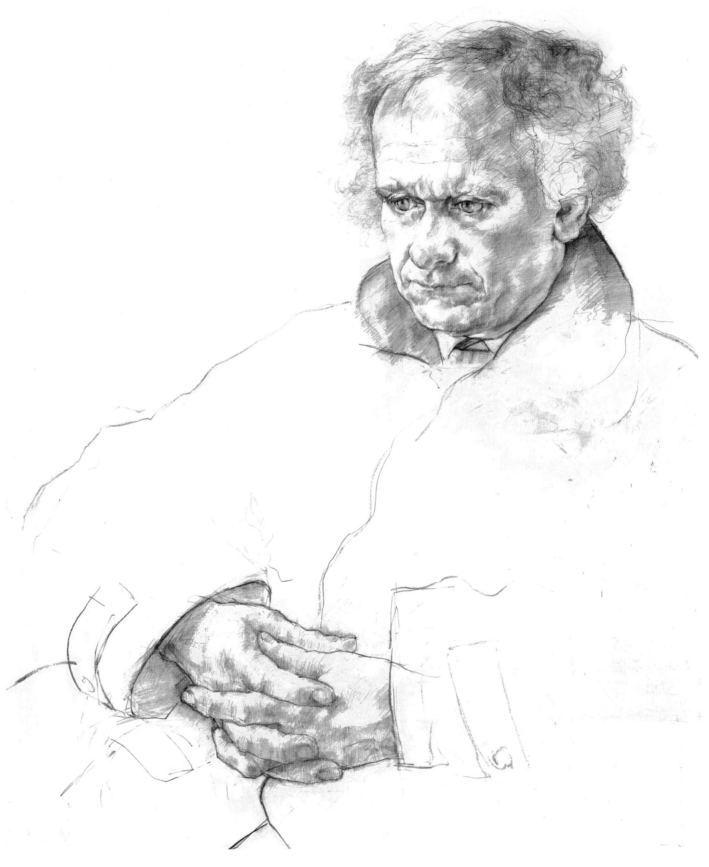

DS, 2002.

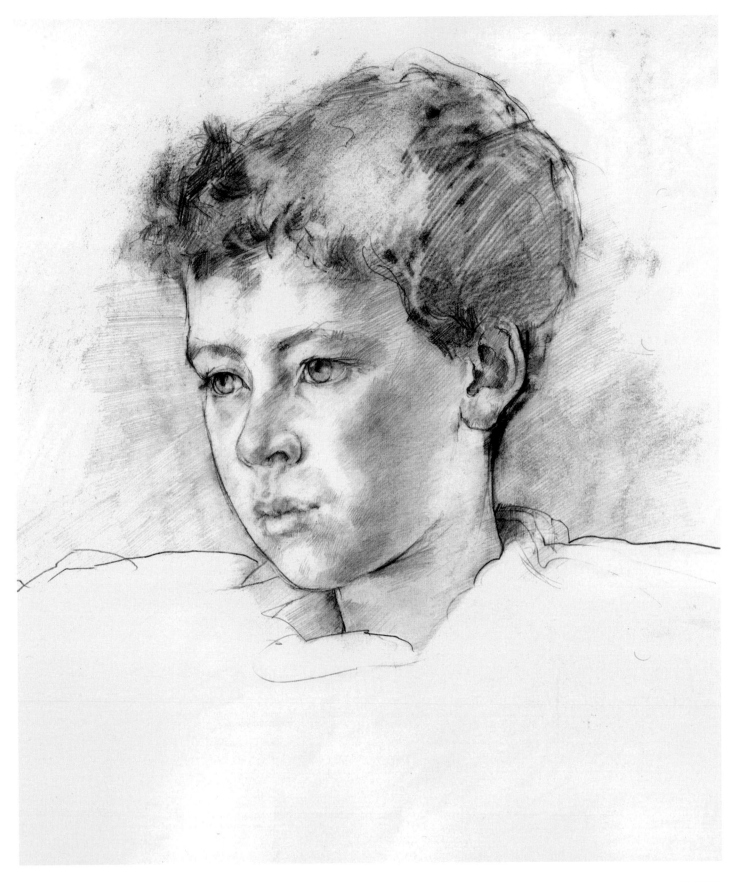

IC, 2003.

MD, 2010.

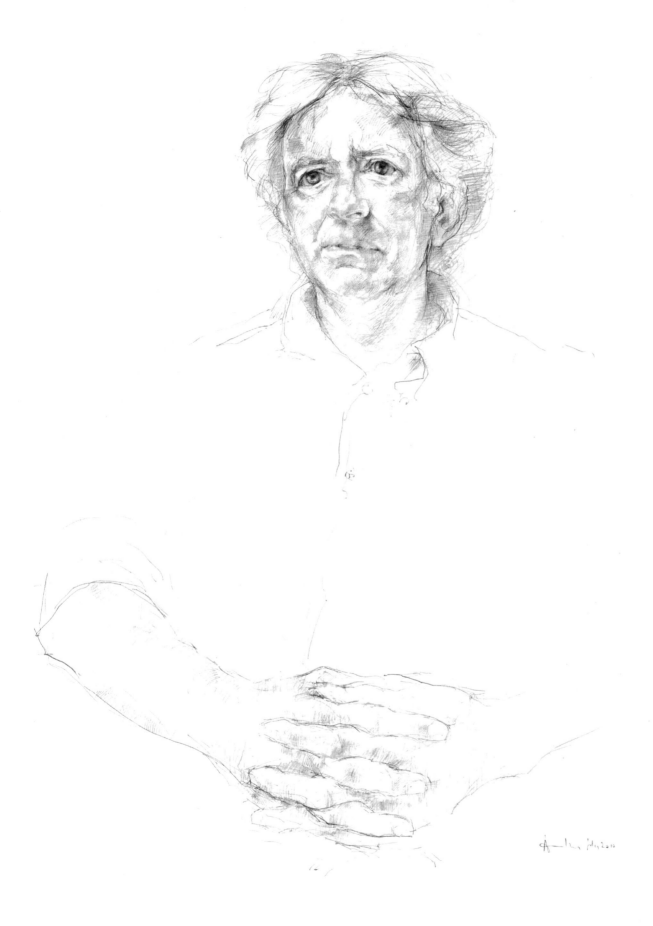

NR, 2010.

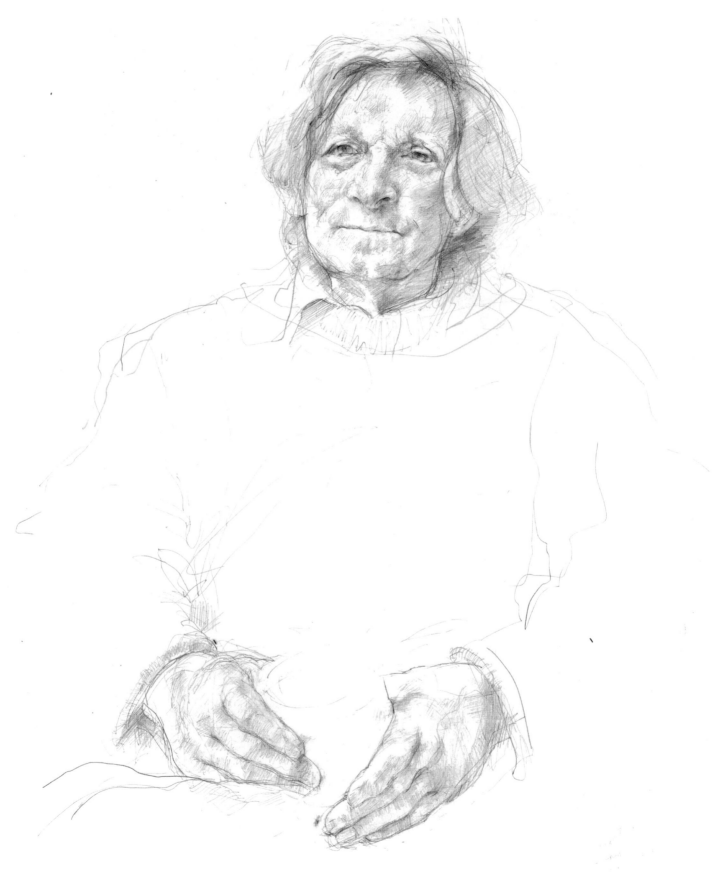

RB, 2010.

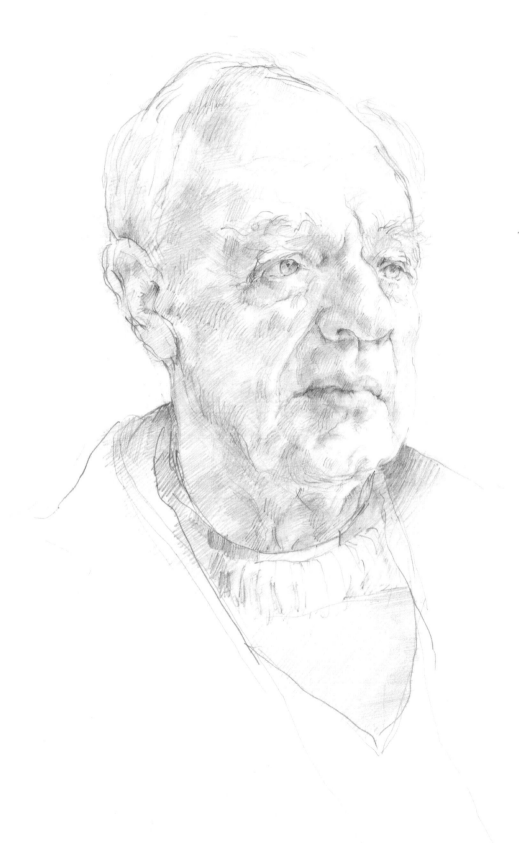

RRSJ.

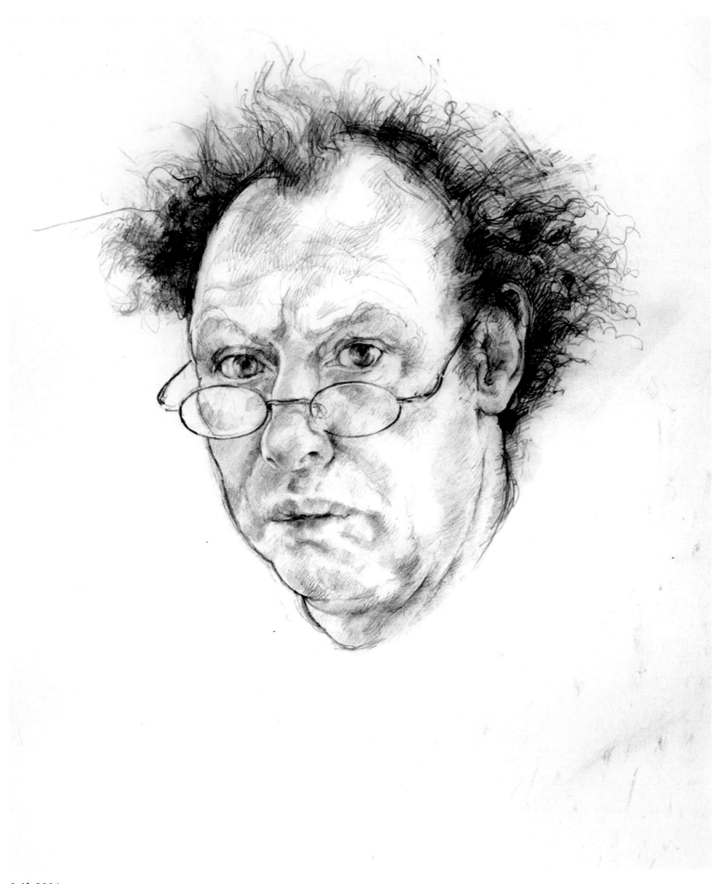

Self, 2004.

The Practicalities

If you want to know, and understand, what somebody looks like, if you want to gather some sense of the space another human being occupies, of their presence, then draw that person. It is almost certainly a mistake to look for the literal. Look for a shape, study the geometry, isolate the light, explore the shadow.

Consideration given to the choice of support (paper, board) and medium (pencil, charcoal, pastel and so on), should derive from one's experience of drawing. Deliberations about which pencil to choose need not precede that experience. Drawing has to do with looking and whatever intrudes is unnecessary. A drawing is an investigation, a record of a discovery, consequently the draughtsman must begin without an outcome in mind.

I begin the drawing by looking closely at the sitter's right eye. I spend quite some time trying to find the particular shape of the eye as it sits inside the skull, protected by the eyelids. The lids wrap themselves around the eyeballs in quite particular ways and I try to trace these particularities with the pencil (1).

Next, I strengthen the drawing of the eye and the area immediately surrounding it (2).

Some refining of the eye follows, with particular consideration given to the eventual tonal contrast between the darker eye and the forehead, cheek and nose (3).

The drawing now moves away from the eye in search of the location of the other features. My eye flits between the sitter's iris and his nostril, checking that the angle and distance are as accurate as possible. The line of the nose also merits particular attention (4).

Now drawing in the nose and making some tentative marks to place the left eye (5).

The gap between the nose and the mouth is critical. The anatomical name for this part of the face is the philtrum. The drawing of the mouth is speculative at this point (6).

Having made a proposal as to the position and shape of the mouth, I now begin to describe the jaw and chin (7).

4

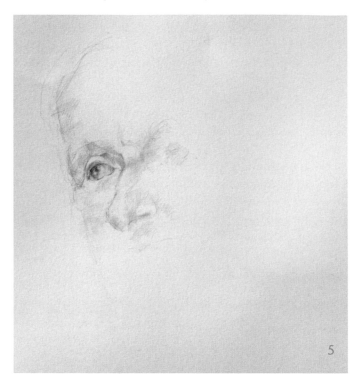

5

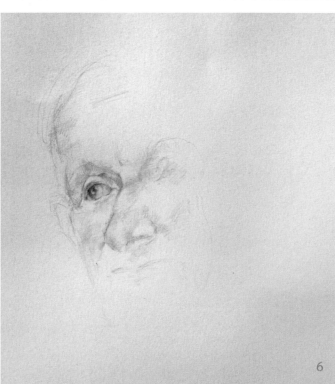

6

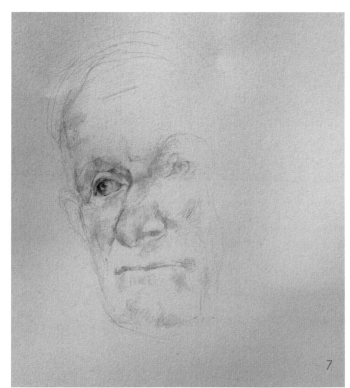

7

Looking across to the other side of the face, I make some marks
that will define the neck and the width of the head (8).

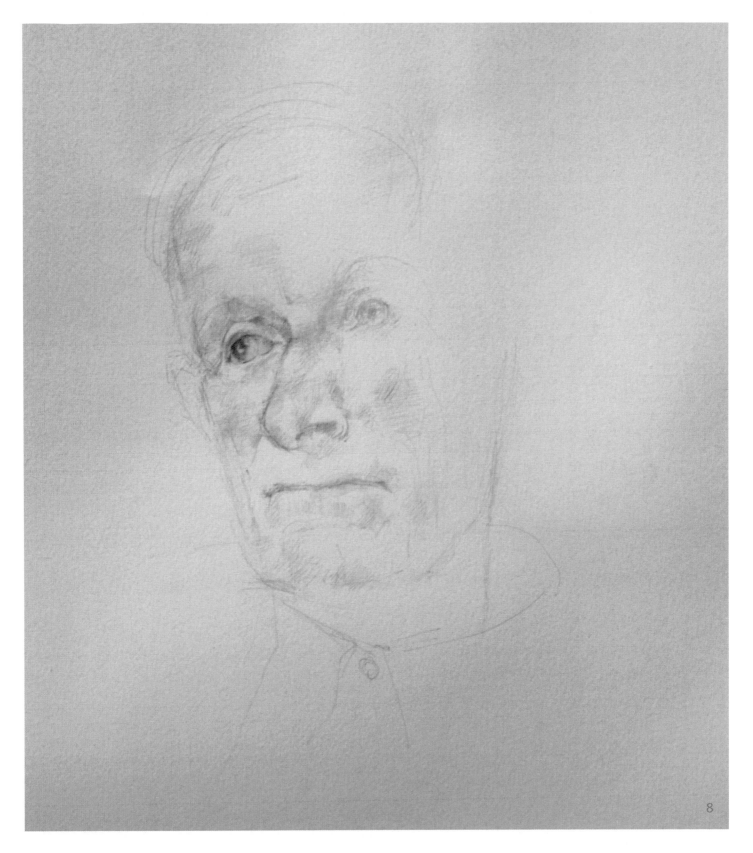

8

The forehead is now drawn in and the whole head can be seen to acquire a form. Refinements include redrawing the line of the nose, which is more aquiline than I initially thought (9).

Because the mouth appears to me not to be working, I remove it, at least on one side (10).

I draw in the shadow falling down underneath the nose and look again at the mouth (11).

The whole right-hand side of the drawing is worked up and I look at how the column of the neck is rooted inside the collar of the shirt. The right eye is also revisited (12).

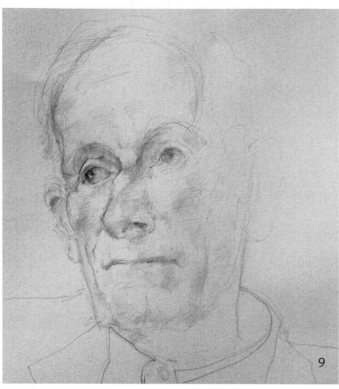

9

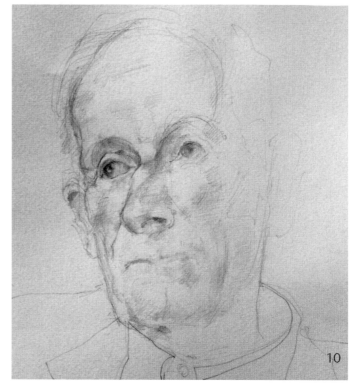

10

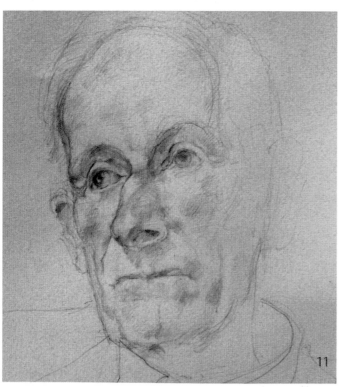

11

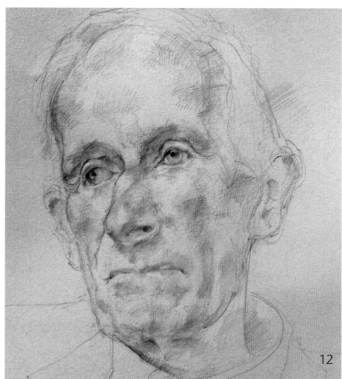

12

The finished drawing.

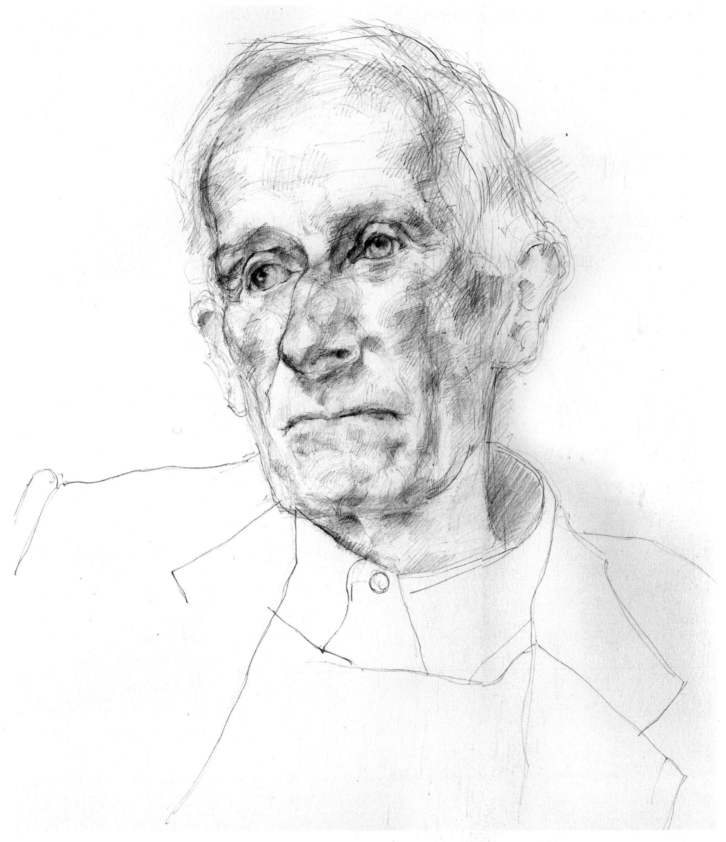

PR, 2011.

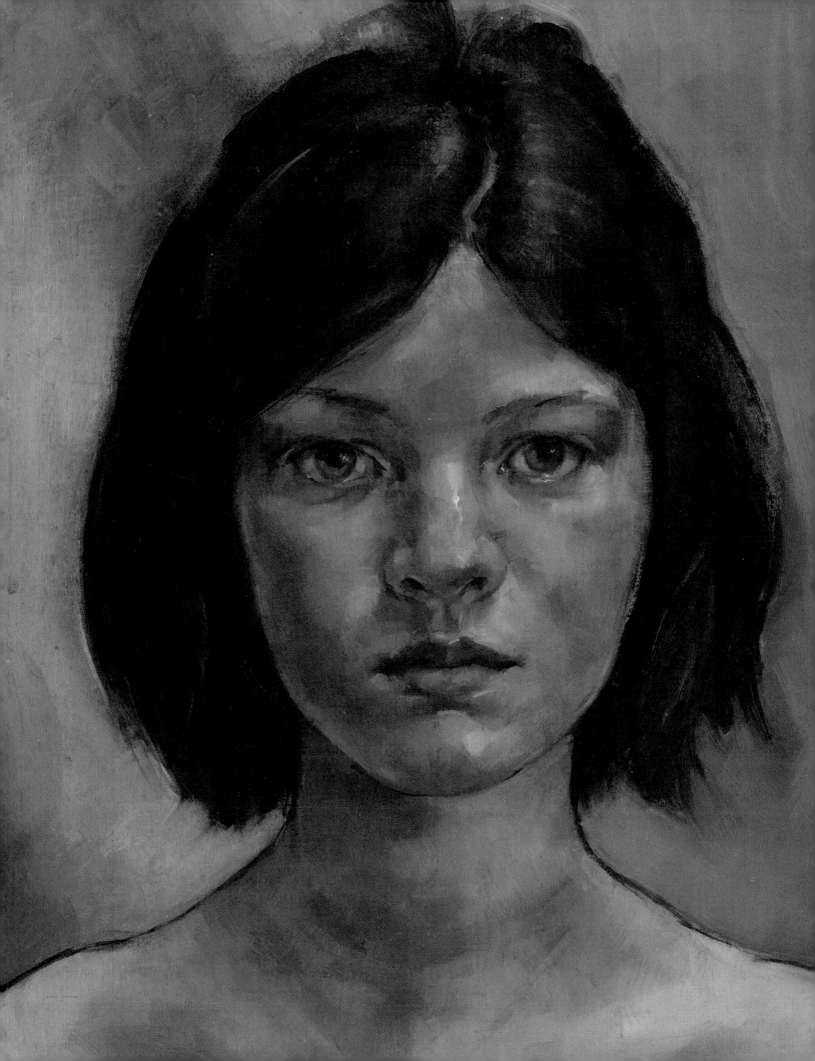

PAINTING A PORTRAIT - 1

Building the Painting

The subject is a girl, head turning slightly away from the painter. The pose is uncomplicated, but not a mugshot. The eyes are looking just past the viewer and, obviously, the painter. Because I am going to make the head more or less life-size, the head alone will take up most of the canvas. I will probably deal with the background as empty space rather than try to squeeze in details that might simply detract from the head itself. The head is enough to engage the painter and produce an intimate portrait.

The support for this painting is stretched canvas and the size is 10in × 14in. This is the ordinary prepared canvas that can be bought in any art shop already stretched and primed with an acrylic primer.

LEFT: *Noni.*

I begin by scrubbing some Burnt Sienna, mixed with a little lin-seed oil and turpentine, into the canvas. This is then left for a short time so that it starts to settle into the canvas and becomes slightly sticky (1).

The residue is then rubbed off with a clean cotton rag. The Burnt Sienna gives an immediate warm mid-tone on which to start drawing the painting (2).

The beginning of the painting is the drawing. I want to establish a likeness and am not at all concerned with colour at this point. That said, I always find Burnt Sienna so rich in colour that it would be difficult to ignore, and not to enjoy, the leaching out of yel-lows and reds, even blues. I begin by placing the features.
The task commences with laying out some basic proportions, still using Burnt Sienna. The relationship of eyes to each other, to the nose and to the mouth form the geometry of the face. That geometry, devoid of almost all detail, will still produce the beginnings of recognition, a likeness (3).

I tend to invest quite a lot of time and effort building and amending a likeness. Corrections accumulate, sometimes to form the likeness of the sitter, sometimes to be rubbed out. The drawing proceeds from very basic outlines to more refined observations (4).

Observation is the raw material of drawing. The quality, and indeed the quantity or frequency, of that raw material, observation, will be a determining factor in the quality of the outcome, the drawing. Here, the representation of the head begins to take on a shape and even a little weight. I am still working only with Burnt Sienna, but already the tonal range is expanding, the eyes for instance becoming darker (5).

At this point I introduce some Flake White. The likeness is still far from secure, but the introduction of a few highlights might help to assemble that elusive geometry of recognition (6).

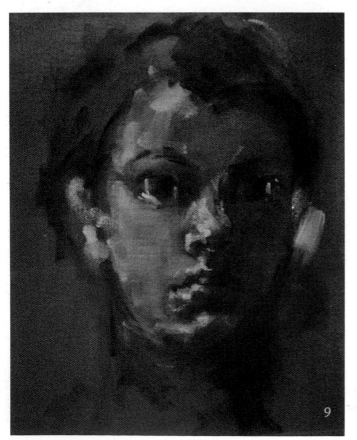

I am still reluctant to focus too much on individual features. The painting currently still resembles a red chalk drawing, heightened with some white (7).

The next illustration marks the beginning of the second sitting.

As this initial drawing phase progresses, it can become very obvious that the likeness is slipping away. This is most usually because the painter is dwelling on a particular feature or a dominant highlight; overworking a particular part of the painting because of uncertainty. He or she may have got stuck and can't see anything else to paint. This probing and halting seems to me to be an integral and important ingredient in the painter's response to the real, tangible person and problem in front of them. It is in part this accumulation of imperfection that the painter works through, mends and resolves, which will give the finished painting its value. Painting from life is technically far more demanding than painting from a photograph. I hesitate to say that 'more demanding' can also mean 'more rewarding', but it will bring different qualities to a painting.

So, to lose the likeness is not to lose the painting. The head you are drawing or painting at this point is still like a lump of clay, malleable and forgiving (8).

I now start to reinforce some of the shadows, while still searching to shift features if necessary, looking, as it were, for some encouragement in the painting. If the painting is not going exactly as you might hope, it is possible to become embedded in a particular feature and to worry that morsel so much that you almost literally paint yourself into a cul-de-sac. There is a remedy for this malady – distance (9).

Distance

A painter can procure distance in various ways. Most importantly, there is the distance of time. Don't hesitate to walk away from a painting that isn't going well. Put a sheet over it, go and do something completely different, then come back to it the following day. The painting won't look the same as you remember and your perception of the problem will have changed, even if only slightly. Be prepared to give yourself some more time, looking at the painting and the model together, without going anywhere near a brush.

The second device is the distance of space – physical distance. John Singer Sargent's sitters would describe how the painter would spend the whole day walking away from the painting, turning, staring and then marching back to the canvas, only to walk away again after a single brushstroke. Take a few steps back from what you are doing, spend some time considering both canvas and model. This method of painting has become known as 'sight-size portraiture'.

Another device is one I can only describe as the distance of illusion. I often take a small mirror and regard both sitter and painting in it. It is then possible to see quite clearly how the work differs from the subject. This is a technique that might require some persistence if it is to be of benefit. I find that when I look in the mirror I can very quickly see if, for instance, the model's left eye is drifting away towards the top of the canvas. I will then look at the model through the mirror to see if I can find any correspondence. Often I find that in fact the model's eye does rise in the way I've painted it, perhaps not so much, but nevertheless there is something that is worth noting. The mirror disrupts the way I look at the problem, but it is a benign disruption because it lends clarity.

Leonardo da Vinci reflected upon the use of a mirror at length in his notebooks.

> When you wish to see whether thy picture corresponds
> entirely with the objects you have drawn from nature,
> take a mirror and let the living reality be reflected in it,
> and compare the reflection with your picture, and

consider well whether the subject of the two images are in harmony one with another.

And above all you should take the mirror for your master,—a flat mirror, since on its surface the objects in many respects have the same appearance as in painting. For you see that a painting done on a flat surface reveals objects which appear to be in relief, and the mirror consisting of a flat surface produces the same effect; the painting consists of one plane surface and the mirror likewise; the picture is impalpable, in so far as that which appears to be round and prominent cannot be grasped by the hands, and it is the same with the mirror; the mirror and the painting reveal the semblance of objects surrounded by light and shade; each of them appears to be at a distance from its surface.

And if you do recognize that the mirror by means of outlines, lights and shadows gives relief to objects, and since you have in your colours lights and shadows stronger than those of the mirror, there is no doubt that if you compose your picture well, it will also have the appearance of nature when it is reflected in a large mirror.

Still working only with Burnt Sienna and Flake White, the head

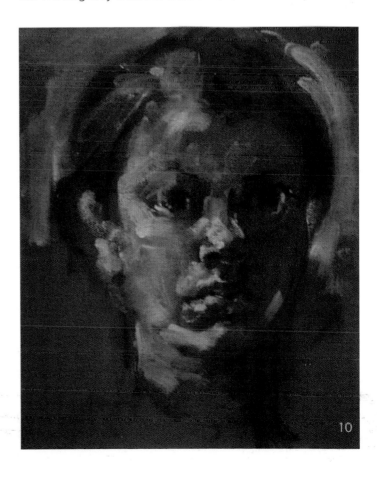

10

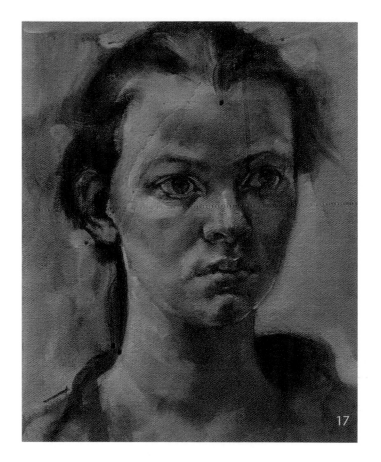

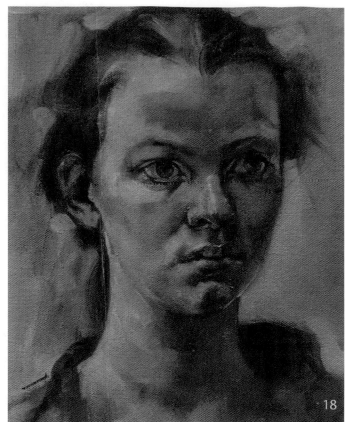

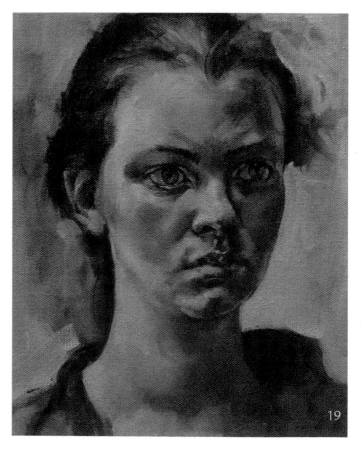

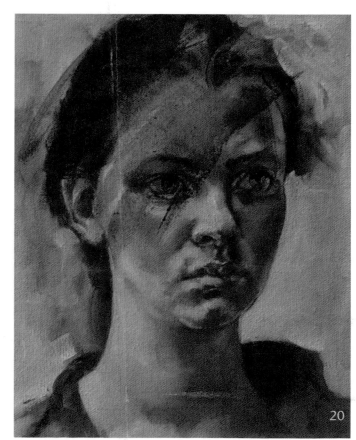

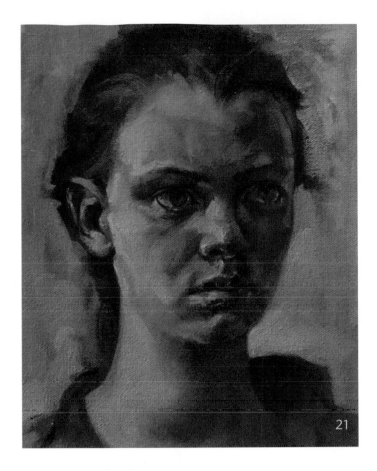

21

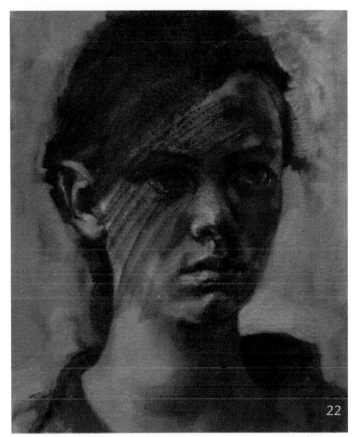

22

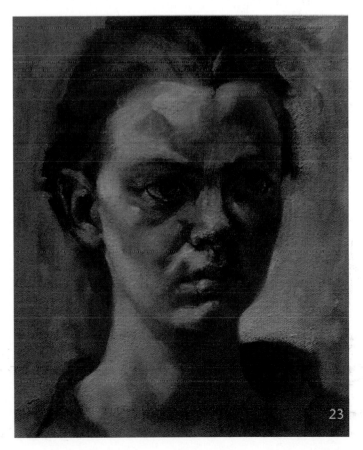

23

A blue glaze is now laid over the surface. The paint has had about a day at normal room temperature to dry a little, so the wet, translucent paint doesn't disturb the underpainting (17).

The paint is spread right across the surface of the face (18).

Once again, looking closely at the model, I start to paint into the face, redrawing as necessary. The blue has a cooling effect over-all, but subsequent glazes will restore the warmth. The blue tints the colder lights on the face such as the chin, jawline and bridge of the nose (19).

A Raw Umber glaze is applied next (20).

As before, that glaze is painted into the picture (21).

A Cadmium Red glaze is, on this occasion, the final colour to be applied to the whole face (22).

The red clearly has to be worked back into something accord-ing more nearly with the model in front of the painter (23).

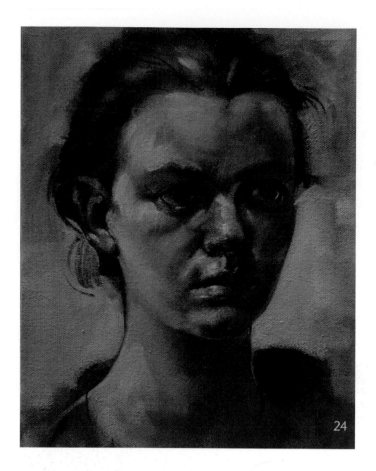

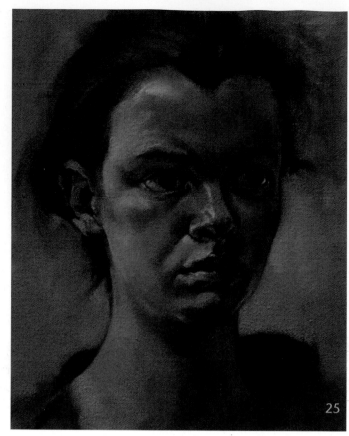

Detailing in the hair, around the head and to the features helps to bring the face back toward a cooler, truer hue. By this stage, I am painting directly from my palette, mixing and applying colour as appropriate (24).

Refining the drawing involves some slight changes to the jaw-line, highlighting areas on the forehead, reintroducing some light near to the edge of the darker side of the face, as well as making the hair somewhat browner (25).

Final changes include putting some grey-blue lights into the hair and changing the background colour, albeit quite subtly and softening some of the highlights with a little localized glazing.

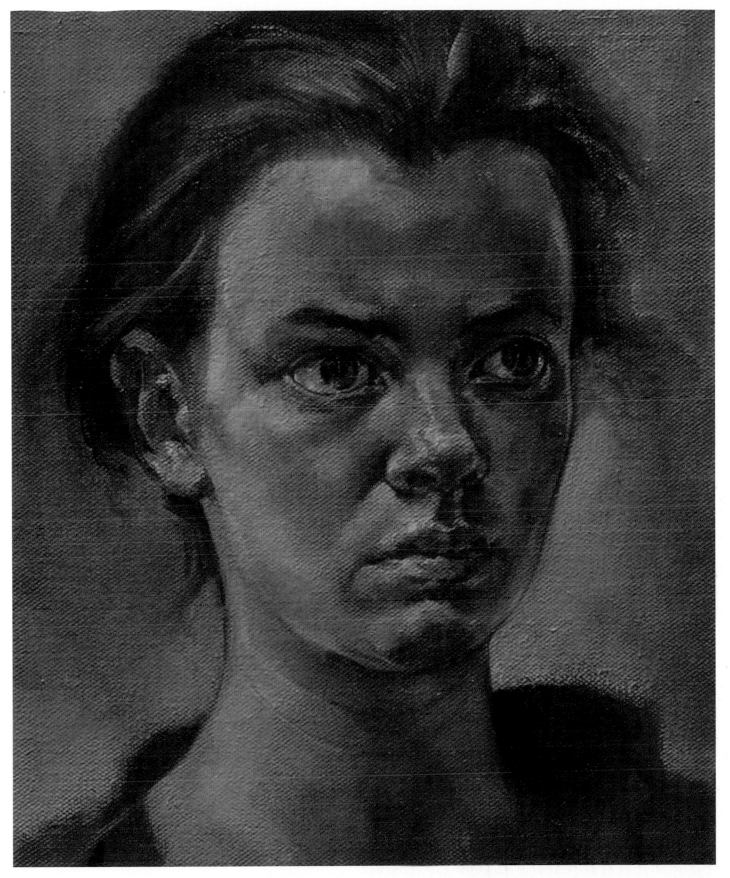

HC, 2009.

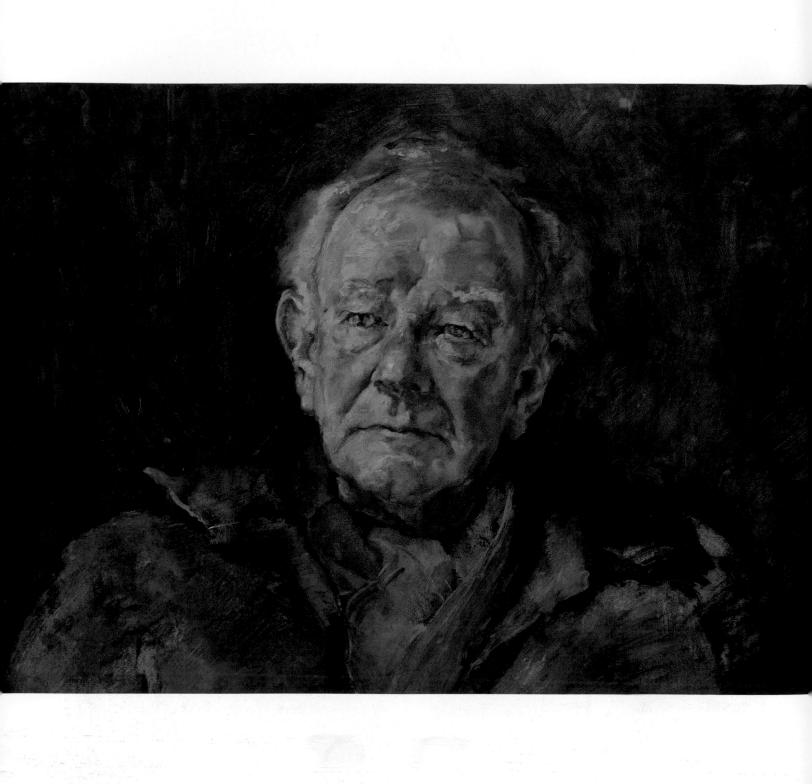

PAINTING A PORTRAIT - 2

The subject of this portrait is a lady who was born in 1919. To say she is elderly doesn't really tell you very much about her; her age is not the most striking attribute of the person. I am not sure that it is always useful for a painter to list the qualities that he or she might want to communicate or include in a portrait. The portrait painter has some obligation to defer to the moment, to the sitter, to the truth, and, when one is presented with ninety years of living, of being human, that obligation seems very clear. That is to say that painting a portrait may present the painter with formal considerations and design problems, but more important than these is the painter's sensitivity to the sitter, to the time that belongs to the making of the painting. Consequently, the only initial decisions I have made concern the size of the canvas and the placing of the head.

Building the Painting

I begin this painting by scrubbing some Burnt Sienna into a canvas that is 80x65cm. Then the paint is rubbed back with a cloth so that I am left with a fairly dry, even surface. The white of the canvas has disappeared and I have a reddish, lighter mid-tone on which to start (1).

I immediately begin to brush in the prominent shadows. I tend to use either the same Burnt Sienna or some Raw Umber, both earth colours. The head is placed within the top third of the canvas (2).

LEFT: *Mr. Rigby.*

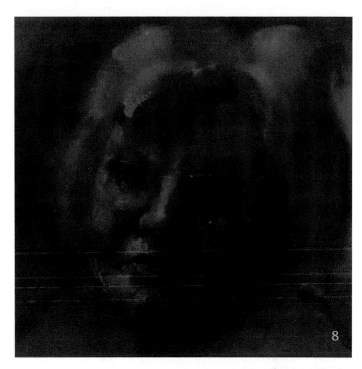

With some Flake White, I then begin to bring out the lights in the face, not just the highlights but also those areas that generally fall under the soft daylight coming in from the left of the painting (the sitter's right-hand side). The paint is still thin and both the image and the actual paint remain very fluid (3).

I then start to reinforce the shadows again with some thin Raw Umber (4).

Because the sitter has a mass of white hair, I put the shadow behind or beyond the head in place. This helps in defining the overall silhouette or shape of the head (5).

At this stage, my overriding concern is the drawing. I have to place the features in their correct geometrical relationships. If I am to be true to the sitter the geometry has to be correct. The eyes have to be the right distance apart and in the proper relationship to the mouth. This, to some extent, will define, and be defined by, the nose. Similarly, the cheekbones have to correspond and also have to hold the weight of the flesh that covers them. I have lightened the background to the right of the head, which again is a defining mark (6).

To this point, the rendering has been quite vague and misty. I now begin to refine the drawing, darkening specific areas: the eyes, especially just beneath the lids, the mouth, nostrils and forehead, especially beneath the hairline. I also put some quite sharp, fine highlights around the spectacles, one eye and the lips. These whites increase both the light and sparkle in the painting, as opposed to the more muted lights on the flesh; the

chin, the nose and the cheek which are there to build and model the head. The shoulder lines are then brushed in (7).

This is the same image enlarged to make the additions and adjustments more visible. This is the point at which the likeness should really start to emerge. If the face is not beginning to be recognizable, I would tend to look again at the basic geometry; try adjusting the relationship of the darks and lights, for example. Like any building or construction project, it is important to measure and check levels from the very beginning and to continue that process throughout (8).

Here I am continuing to refine the drawing by lowering the eye-

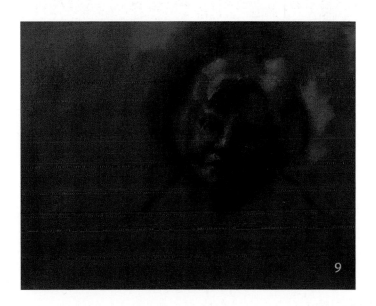

10

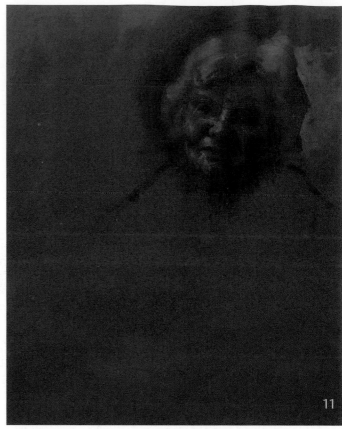

11

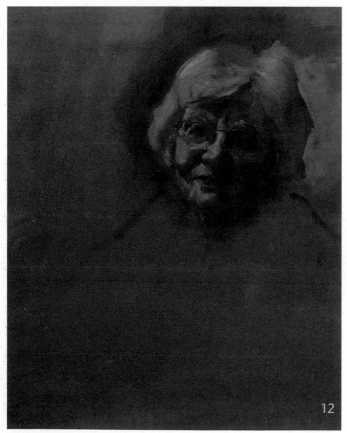

12

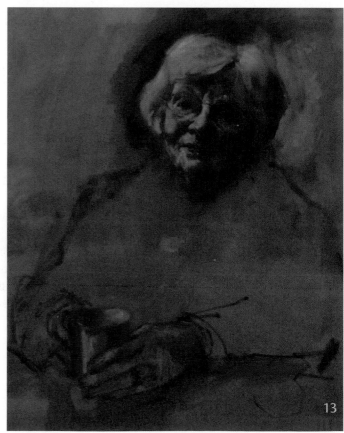

13

brows and the cheek on the right side. I have also made a mark across the right eye; this represents a flash of light on the lens of the spectacles (9).

I have now begun to look quite closely at the texture and feel of the face. The area around the chin is now painted in some detail, still using predominantly Flake White and Raw Umber (10).

Refining can be a long process, but providing the structure is sound it will continue to enhance the painting. At this stage, I am drawing in the outline and some of the detail of the spectacles, while deepening the shadows in the face, for instance around the nose and on the lower part of the forehead (11).

Just the lightest wash of Cadmium Red is added, to begin to bring colour into the cheeks, particularly on the right-hand side and the forehead. I prefer the term 'wash' to 'glaze' for the thinned paint, because this really is more like watercolour. The paint is mixed very thinly and, importantly, very cleanly, with some oil and turpentine. The paint is then brushed on so as to change the colour, slightly, whilst leaving the form very much intact. Glazing like this is about the accumulation of very subtle changes (12).

14

Leaving the face for the moment, I have now begun to place the hands. At the beginning of this painting I had no real ideas about the composition. This is not necessarily the best way to approach a portrait, but in this instance it has afforded me the possibility to observe the sitter and to think about my options. Having placed the head in the top right quarter of the canvas, I have limited my choices somewhat, but within that constraint there is some space to manoeuvre. For instance, I initially placed the hands much lower down the canvas and without a cup. It seemed to me that this made the hands seem over-large, so I pulled them back toward the model and, seeing the cup in the sitter's hands, thought this arrangement might work (13).

Drawing the hands seems to me to be very important. I would not go so far as to say that they communicate character, but they can be very evocative. In this instance, the cup provides the perfect support against which to rest the sitter's left hand, on which she wears her engagement and wedding rings. I have begun painting the hands in exactly the same way as I did the head, that is, drawing the outline in Raw Umber, correcting it and then working in the lights with some Flake White.

The painting of the cup is more direct. It is preferable to bring on the cup and the hands together. I would find it more difficult to make the hands fold around the cup convincingly if the latter was just sketched in (14).

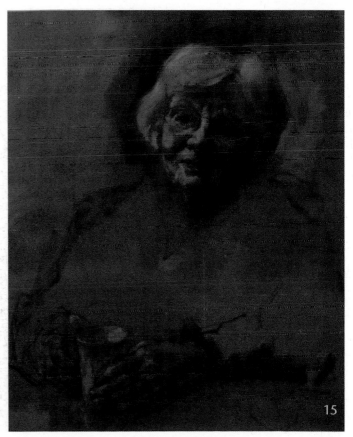

15

At this stage I am refining the drawing, particularly of the sitter's

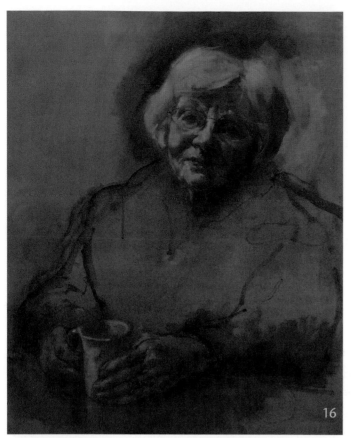

16

right hand. At the same time, I have begun to smooth some paint into the table top and made some suggestion of a reflection on that surface. I am still working primarily with Raw Umber and Burnt Sienna, but have also introduced a little transparent Cadmium Red to warm the left hand slightly (15).

The forms around the hands now begin to acquire some weight. The table top is darkened and the coat begins to take shape, initially from the wrists upward. The paint is still being applied very thinly, with the occasional exception of the Flake White, which in places is left relatively thick.

It may seem rather obvious to say, but the way paint is applied can alter its effect quite distinctly. For instance, when I work the white into the table top I tend to rub it back, which gives a sheen to the surface, whereas left somewhat thicker on the hands it begins to suggest the texture of skin (16).

This is the situation in my studio. The sitter is just beyond the canvas. She is at this point wearing a grey coat, some details of which I have begun to sketch in (17).

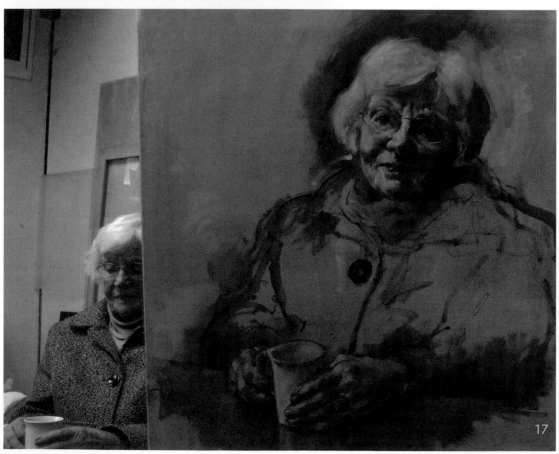

17

Having established part of a setting, a pose and for the moment a costume, I can begin to take a larger look at the painting as a whole. Stepping back, I can gauge how well the head works in relation to the hands and so forth. I have washed some French Ultramarine Blue into the face, then worked into that a little with some white. In the same way, I have glazed the blue onto the hair, particularly on the right-hand side of the picture, and then worked back into the wet blue paint with some white (18).

Having thought at some length about the grey coat the sitter was wearing, I have decided to change it. I felt the grey rather sank into the painting and that I wanted to bring the sitter forward; the grey was just too grey. I think the subtleties and warmth of the head and hands might work better against the blue (19).

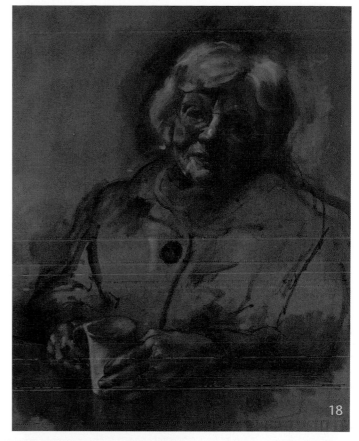

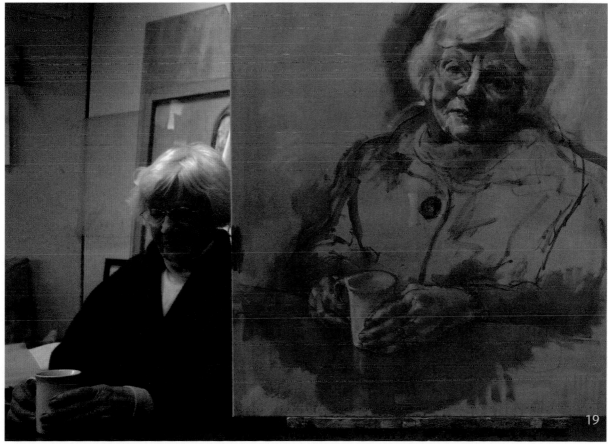

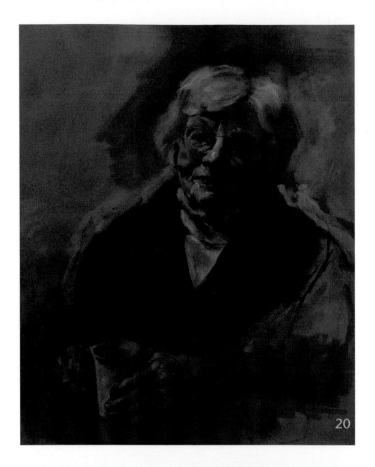

20

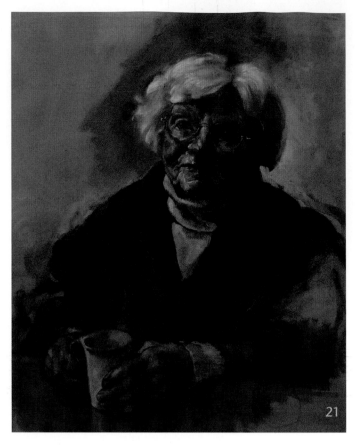

21

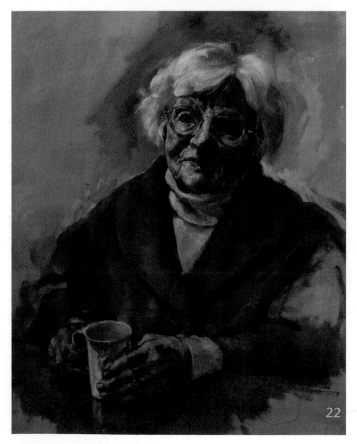

22

Here, I have gone over the outline of the grey coat and painted in the light blue polo neck, which, being a colder colour, helps to increase the temperature of the face. At the same time, I also reduce the bulk of the figure, pulling the coat in around her small frame (20).

The painting now begins to take on some subtleties and presence. Several elements change significantly at this point. The hair is worked into and defined. Highlights are carefully introduced. The face is more closely detailed. I do this principally by washing colour onto the surface, and then working into that with whites that have been mixed with tiny amounts of Yellow Ochre or Burnt Sienna and sometimes French Ultramarine Blue. These colours are added in a way which I try to make as nuanced and delicate as I possibly can. The warmth in the head comes primarily from the purer glazing colours, especially Burnt Sienna and Cadmium Red. The modelling and detail is more dependent on the more opaque colours based in the white (21).

The shadows are now worked up, that is, darkened, for instance in the costume behind the hands. The eyes too are washed with some Raw Umber to make them a little deeper (22).

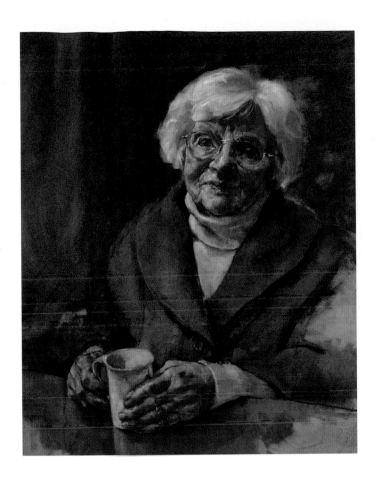

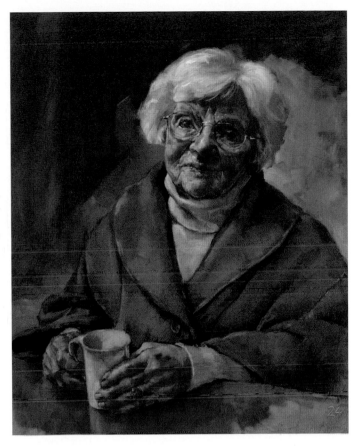

In an attempt to unify the background I have now washed in a base of Cadmium Red. It seems to me immediately that this is too loud, so I begin to work back onto the surface with some blue-greys made up of Flake White, French Ultramarine Blue and a little Raw Umber (23).

I am also concerned to put some light to the right of the sitter's head. Because that side of the head is in shadow, it can be helpful to reinforce the illusion of depth by giving the eye the possibility of entering the space behind the figure. In a way, one is creating air to the side and behind the sitter (24).

I have now pushed all the red back and continued to work up the detail both in the figure and in the costume. Shadows have been deepened in the face primarily with Raw Umber, for instance in the cheeks. Small adjustments have been made in the drawing, to the chin, for example (25).

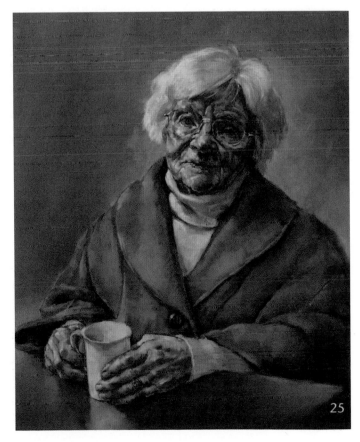

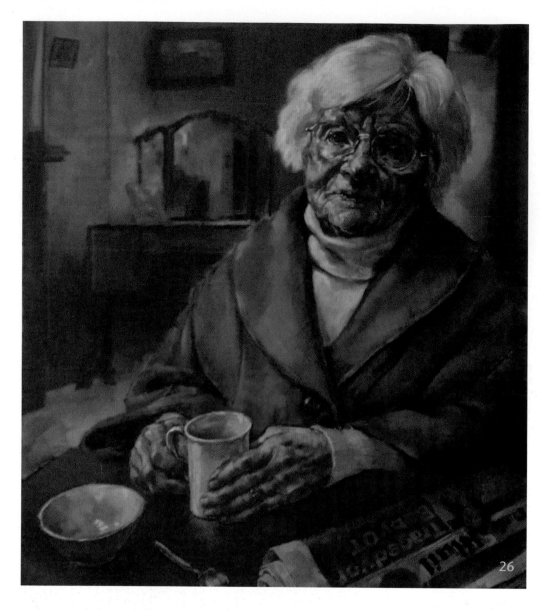

26

Having more or less resolved the figure, I now begin to construct the background. The objects chosen are relevant to the sitter, but quite often the placing of those elements is dictated by the picture. For instance, positioning the doorway just to the right of the figure provides a light which substantiates the shadow on that side of the head. The bowl, spoon and newspaper are placed to make the foreground more hospitable, more accessible (26).

In the final resolution, some of the background elements, such as the details on the extreme left and the picture frame above the dressing table, are softened away, to 'unclutter' the picture. The doorway is made lighter and brighter, with some Yellow Ochre and Flake White.

Whether or not I realized my intentions is a ticklish question,

particularly if one is vague about intentions. Because painting exists slightly on the periphery of necessity (we could live without it), there is no very clear consensus about its function. Artists are often unsure about what they want until they see it. Painting is a speculative activity. Some contemporary painters, when asked about their practice, will talk about journeys, enquiries or 'a private quest'. In contrast, other painters will seem very clear about what they intend, for example David Bomberg 'seeking the spirit in the mass'. But then the 'spirit in the mass' isn't exactly a quantifiable entity.

The picture is, I think, a good likeness. For a portrait this is quite important. It is an affectionate likeness and, in this instance, I also feel this is important. I think it will make the sitter seem present in ways that wouldn't otherwise be possible. The painting then is functional, intentionally or otherwise.

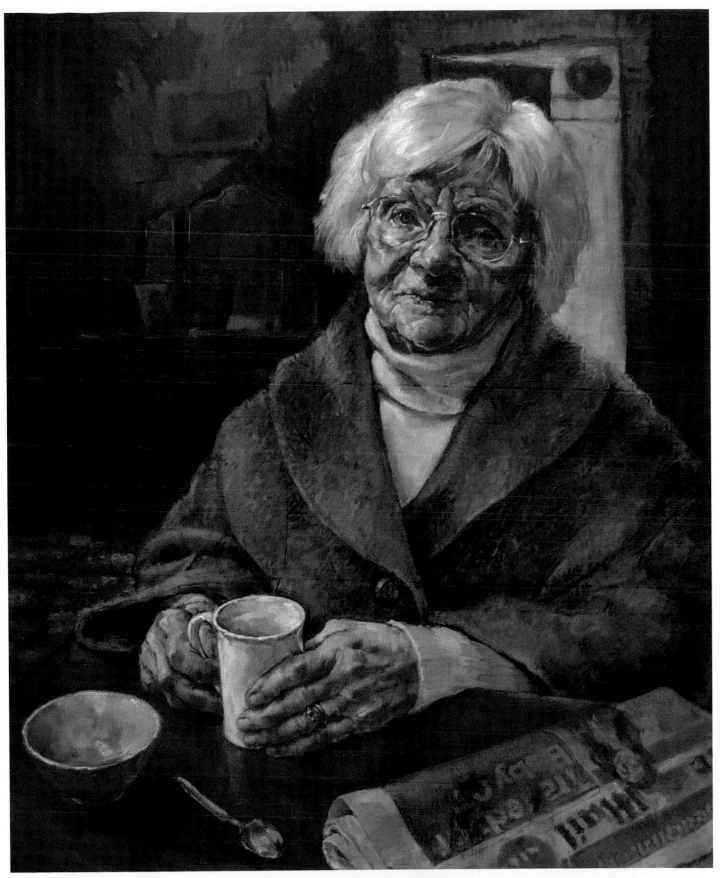

Mrs. Honoria Edmondson, 2009.

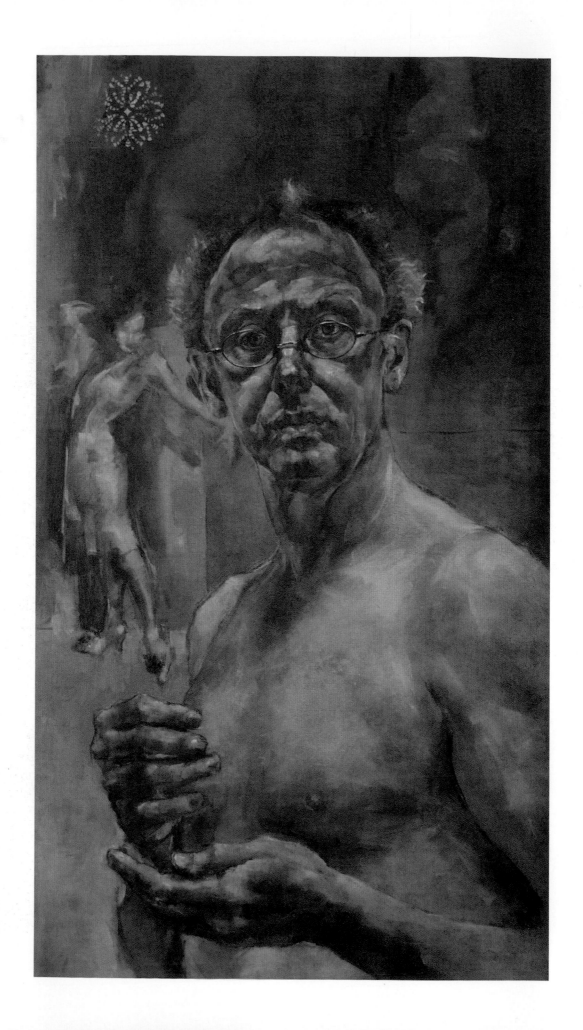

THE SELF-PORTRAIT

The real pleasure in painting oneself is that there is no compulsion to flatter or to please anyone else. You are the commissioner, the customer, you can delight yourself. We, most of us, will probably have in our minds a self-image; all we have to do is make it visible in paint. Our ideas of ourselves may be sympathetic, flattering even. To the extrovert, the prospect of representing oneself may seem an exciting opportunity. The introvert might prefer to seek to establish to what extent his ideas about himself actually correspond to the truth, to what is actually before him in the mirror. It would be too simplistic to characterize these two approaches as self-presentation and self-exploration. Certainly notions of exteriority and interiority flow into each other when one looks at, for instance, a Rembrandt self-portrait. A painter like Rembrandt moves from one to the other easily, often combining self-publicity with searing introspection. An interesting contemporary comparison might be made to an artist such as Tracey Emin. Rembrandt might have considered it unnecessary (or even uninteresting) to expose himself by smearing the carnal details of his life across paper and public spaces in quite the same way, but the honesty in both cases, I would say, is nonetheless genuine.

Similarly, Dürer's honesty is difficult to question. He is possibly the first artist, in the history of so-called Western art, to depict himself naked. This drawing does not intend to shock. The astonishment is simply that of a man considering his own mortal nakedness.

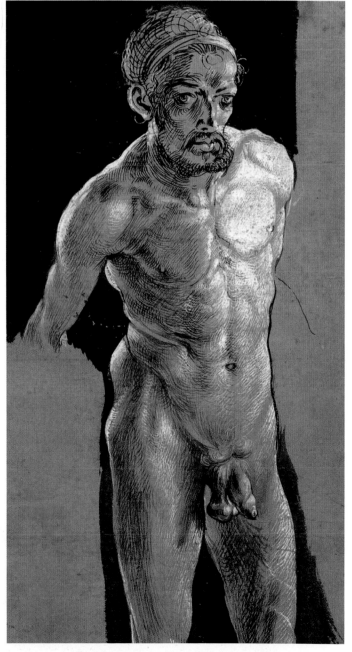

Albrecht Dürer, *Self-Portrait* (1500–1512)

(although Charles Laughton did make a rather sympathetic Rembrandt in the eponymous 1936 film), but his self-portraits are, by many definitions, beautiful. A successful self-portrait leaves nothing out. As Kenneth Clark says, Rembrandt opened his heart. He compares Rembrandt's self-exploration to reading the great Russian novels of Tolstoy and Dostoevsky. There is quite often in this painter's self-image something grand, something royal. He dresses himself up in a way that might (must) have seemed garish or vulgar to his Protestant compatriots in their black coats and white collars. There is quite often 'something of the closet' about these paintings, especially the earlier self-portraits. He clothed his imaginings. This indulgence is so frank, however, that one is never tempted to regard Rembrandt as a fop or a braggart. There is such a degree of relentless self-scrutiny here that one has a real sense that illusions or delusions, if they intrude at all, are immediately known and discarded for what they are. This is the joy of self-portraiture, the possibility, the desirability of serving only one master, which ironically is not the self, but objective, harsh, necessary truth. Again, the irony is that the cold eye of truth can produce an intense human warmth, an expression of humanity and a deep sympathy with and for the subject.

It is human, of course, to want to present oneself to the world in at least a sympathetic light, to indulge in a little fiction. There are undoubtedly painters who are so lovely to the eye that it would be falsely modest of them to stray from the truth. Courbet certainly seems to have been a particularly handsome young painter. Self-satisfaction, however, is not an ingredient of interesting self-portraiture. Dürer, almost certainly, didn't depict himself naked because he thought himself an Adonis. When one looks at that naked figure, one is looking at a man who was desperate to know what he looked like, not because he felt himself to be beautiful, but because he knew himself to be vulnerable, and the drawing reveals just how exposed he was.

Despite intimations to the contrary, we do know what we look like. There is a danger that when painting a self-portrait, as a consequence of this knowledge we can become inattentive to the eye, relying too easily on our preconceptions of ourselves. The more you paint yourself, the more this becomes a danger. There should always be something of the 'is this really what I am seeing?', some surprise, in the painter's mind.

The Practicalities

Setting up to paint a self-portrait is rather different to preparing for a portrait of a sitter. I like to work close to the image, so have put two easels next to each other. On the easel to the right I have mounted a mirror; on the left, the board on which I am going to paint. I want to be able to move my eye easily from reflection to painting and back again. The action of moving the eye from canvas to subject and back is called a saccade. This word

The practicalities – the easel and the mirror

describes the flicker of an eye as it compares and evaluates the correspondence between the marks made with the subject. It derives from the French, saccader, meaning to jerk or jolt.

The ground for the painting is gessoed board. I have then brushed on some diluted Burnt Sienna and rubbed it off again to leave a thin, not quite dry, coloured surface (1).

I begin painting by trying to establish, approximately, areas of shadow. I am also conscious that I am placing the head within a frame. This means that I have already given some consideration as to what I want to include in the painting. I could, for example, take the full face to the very edges of the board, or reduce the size of the head in order to include more of the torso, even the whole figure.

For this painting, then, I have decided to deal with the face in some detail and also to show the whole head. I particularly want to see some space around the head, because this will help me to create some 'air' around the bulk of the head and should, if managed properly, enable me to add weight to the head (2).

I wear spectacles and find them very useful as a kind of constant. Because they are rigid, unlike my face, I can use them to measure distance and to judge how the head inclines. Of course, they move around on my nose, but if I can mark a par-

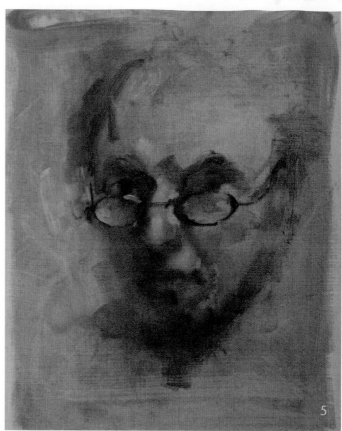

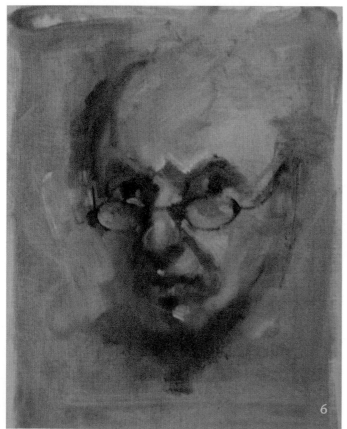

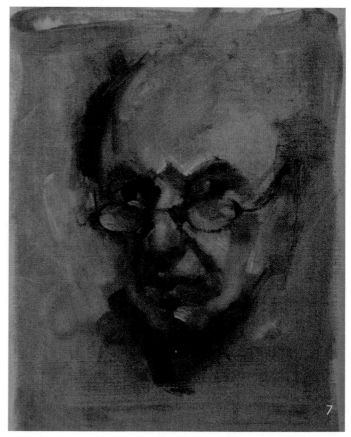

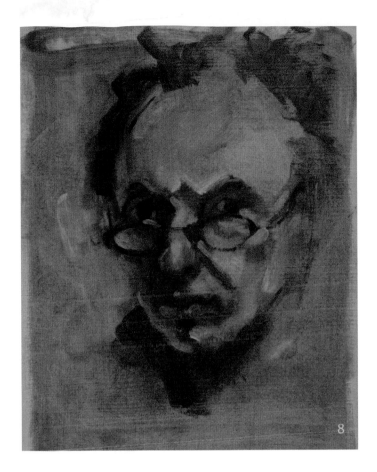

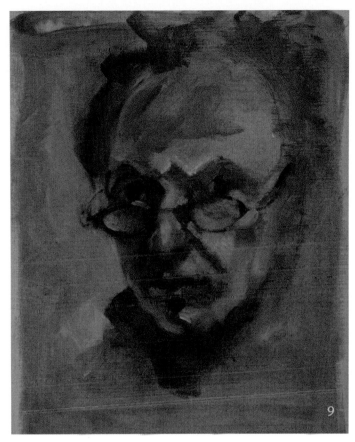

ticular point on the bridge of the nose then place them there, it can be like holding a fairly accurate measuring device in front of the image I am trying to capture. Spectacles need not be a complication; they can be very useful (3).

I can then begin to refine the drawing, introducing some lights and cutting away at the profile on the left-hand side of the face (4).

The painting starts to become a little heavier, thicker, at this point. I have introduced some red into the cheeks and reinforced the highlights somewhat (5).

Coming back to the spectacles, I now paint them in much more definitely, along with the shadows under the eyebrows. The painting is still very much a drawing, in that I am using colour to manipulate tone and am still not overly concerned with the qualities that a wider range of colours will bring to the painting. I do find it interesting, however, that defining the lips a little

more carefully with some thin Cadmium Red does introduce expression to the face (6).

Deepening the shadows by laying in some Flake White begins to add weight to the head and give it a sense of presence (7).

The profile is defined further and some light brought to the left-hand side of the picture by darkening the background with Raw Umber (8).

Drawing the spectacles again. It is rarely the case when painting that any element can really be said to be finished until the decision is made to leave the whole painting. Until that point, when you feel that every part is balanced, often precariously balanced, and that the whole structure is holding together in some meaningful or satisfying way, a change to any part of the surface can have unforeseen consequences for any other part. I have also added darks to the hair, which in turn adds solidity to the head (9).

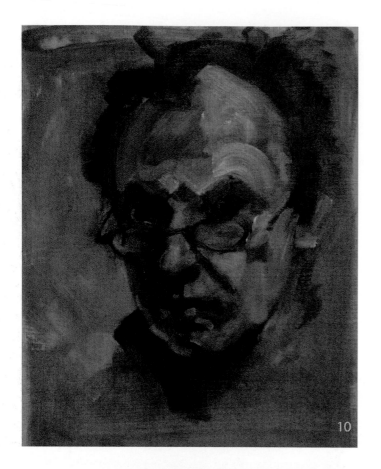

10

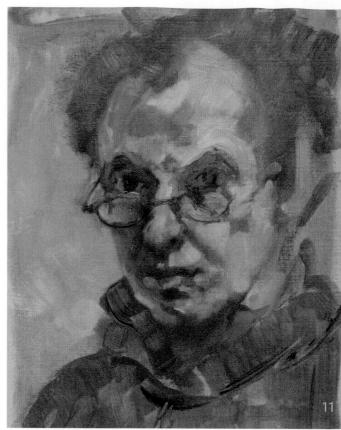

11

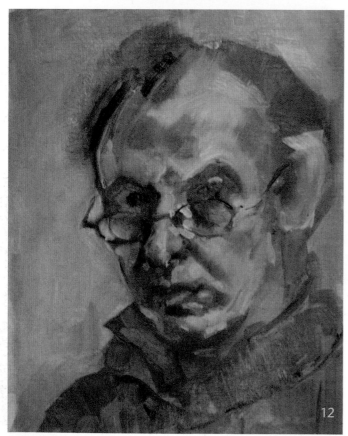

12

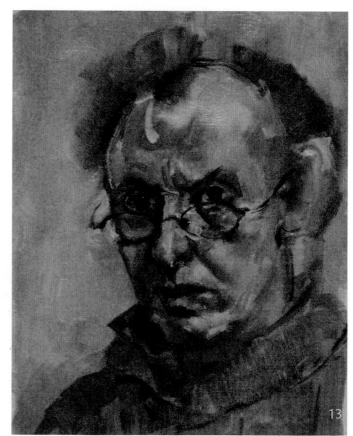

13

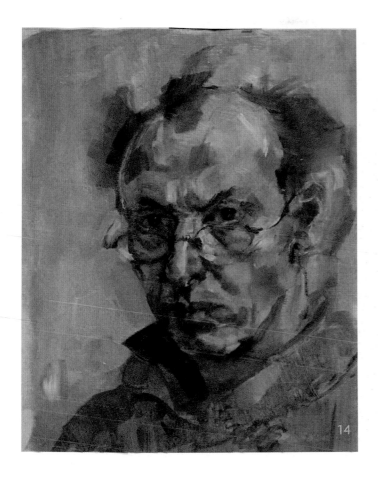

14

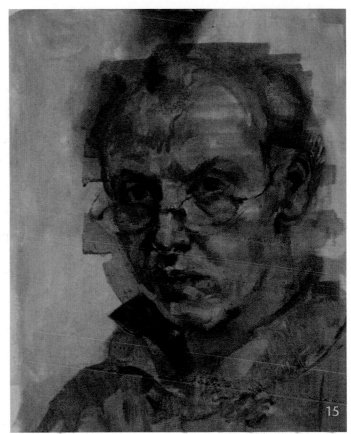

15

Next, some French Ultramarine Blue is scrubbed into the shadows, particularly around the eye on the right-hand side and the darker parts of the forehead. Partly because I am still using white to bring out highlights and to modify the colours themselves, the overall effect is one of chalk and mud. I rather like this, at least at this point. It feels as if I am forming something out of very elemental ingredients, out of the earth (10).

I have now started to use relatively thick paint, primarily Flake White with small additions of Yellow Ochre or French Ultramarine Blue. The modelling, mostly on the right-hand side of the face, is fairly loose, but the jowl is made more visible and the ear appears (11).

The whole painting now begins to have a shape, while remaining quite loose. The shoulders are shaded in and some French Ultramarine Blue is used to increase the shadow to the side of the nose and around the eye socket. The shapes on the surface are still recognizably brushstrokes, coloured grease dragged across a board. Part of the act of painting is to create a union between the medium and the subject; most successful portraits and great paintings manage to bewilder or astonish in their use

of, and feellng for, the medium (12).

The outline is now redrawn, defining and tightening the shape of the head. Any head is like an entirely unique rock; the outline is critical to knowing and recognizing that singular object (13).

Revisiting is a constant and something I tend to do a lot. I go back over and look again at the detail in the features, especially the mouth and eyes. I have increased the shadows somewhat in the eyes by drawing around the lids; similarly, I have looked more closely at the shadows in and below the mouth. The marks made are always speculative to some extent and the rather obvious stroke of Raw Umber on the chin is decidedly speculative. I am really just wondering if the shadow there is so deep. By then stepping back from the painting and looking through half-closed eyes, I can tell if the shadow would work or not (14).

I decide that it is definitely too harsh, but try a similar mark under the chin (15).

The painting has become rather chalky, having been worked

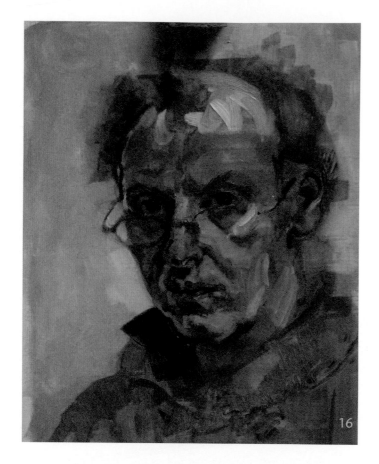

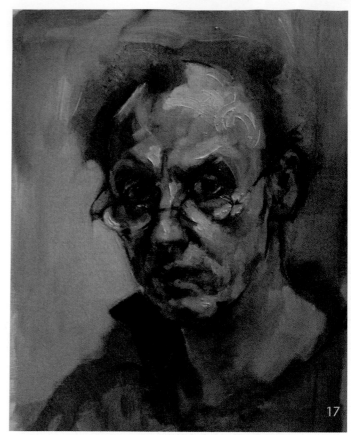

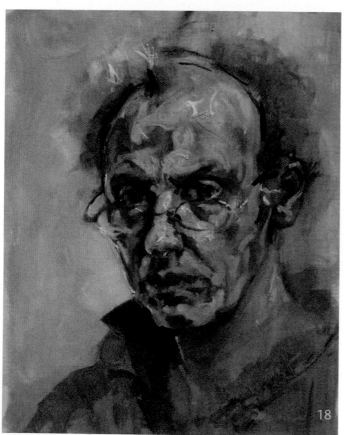

into quite a lot, with various degrees and shades of white. Partly in order to reintroduce some colour and partly to unify the whole painting of the head, I have now glazed over the surface with some Yellow Ochre (diluted with turpentine and linseed oil) (16).

Working into the wet surface, I can now rebuild the highlights and once again look at the profile while painting the background. The collar of the shirt is made darker to help define the chin and some blue is washed on to the hairline, which in turn contrasts with the highlight on the forehead. Partly ignoring the frame of the spectacles, I apply quite a heavy stroke of white to the cheekbone on the right of the painting, with the intention of painting the frame of the spectacles through or on top of this at some point. (17)

I carry on working into the wet surface, concentrating on the highlights. The nose, eyes, forehead, cheeks, spectacle frames and hair all pick up small flecks of pure Flake White, just laid as cleanly as possible onto the surface, so as not to mix with the colour underneath (18).

If we look closely at a detail at this stage, we can also see some of the more subtle changes that are taking place – the blue to create a rather soft sheen to the side of the nose and the touch of grey in the lower portion of the iris, for instance (19).

Another layer of glaze, this time Cadmium Red, seems to cast a pink obscuring veil over the whole painting. There are moments, when looking at a portrait being made, that it becomes apparent that the head is too cold, or too yellow, too pink or too light. This becomes a good point at which to try to shift the whole look of the painting by glazing. It can appear disastrous at first, but it gives you the opportunity to work into the surface again and, most importantly, to look again. The painting underneath isn't lost, just submerged a little, and the wet glaze almost demands that you work into it (20).

I have now painted down some of the red in the background while continuing to define the face. I have also shaded in the collar and pullover (21).

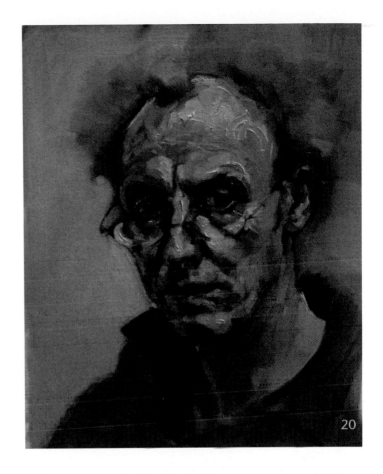

20

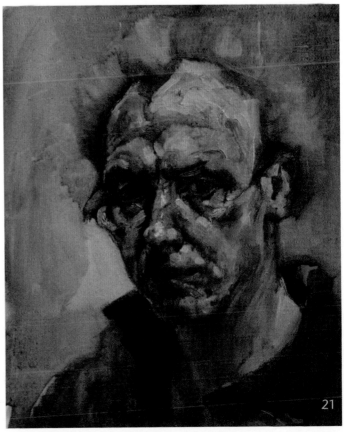

21

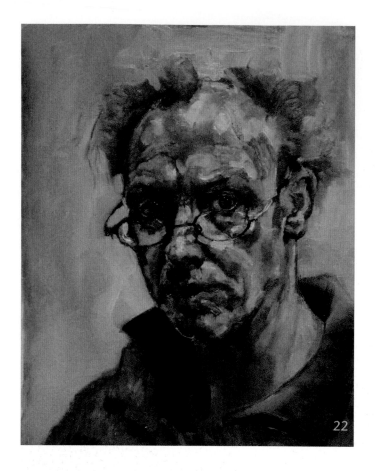

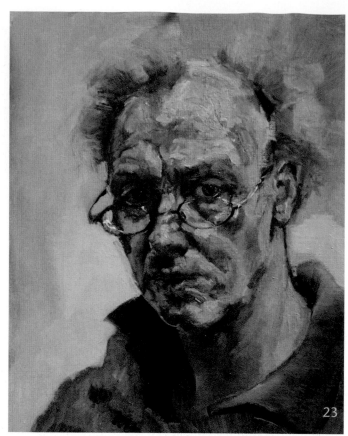

I glaze almost the whole painting with a wash of Burnt Sienna. Again, I then work into the wet glaze, highlighting and working into the details of the features. Most importantly, I am looking again (22).

The painting is now nearing a conclusion, but, even so, relatively small changes can have slightly alarming results. Here I have worked into the face and then put some much lighter paint around and above the head, which gives the picture quite a startling and unforeseen appearance. I have also worked some detail into the jumper (23).

Modelling the dome of the head and working into the hairline retrieves the picture somewhat, from a slightly manic stare to a more studied regard (24).

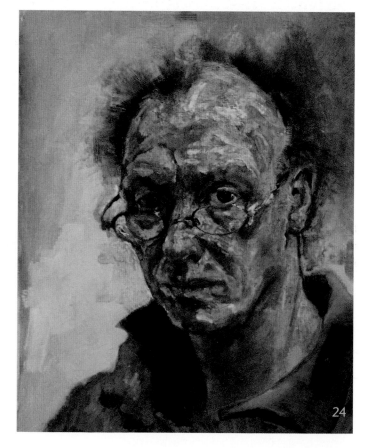

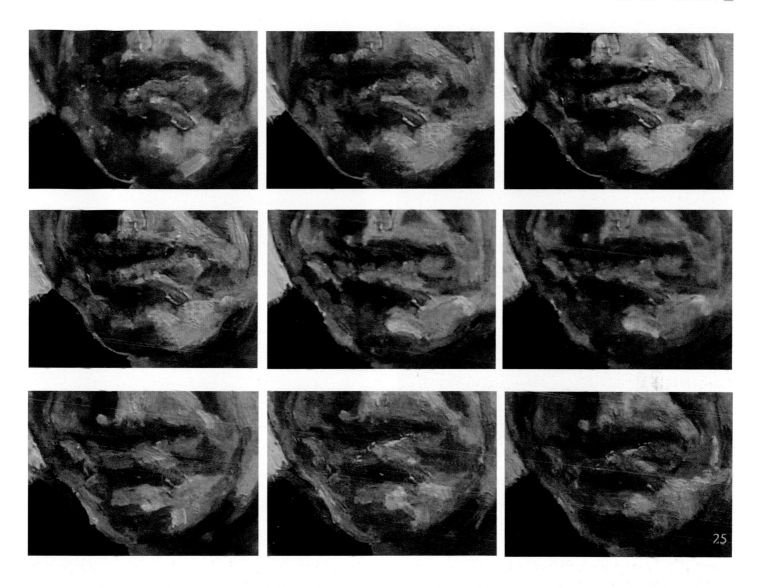

As the painting comes to a conclusion, it is interesting to compare these details and the flurry of changes which move the painting toward a resolution. The sequence begins top left and ends bottom right, with the mouth as it finally appears in the finished painting. Of all the features in a portrait the mouth in its setting is possibly the most telling and informative. That is not to say that getting it right can solve or realize a likeness, but it is one of the necessary attributes of achieving a likeness.

Expression, too, is affected by the mouth. Mood, character, intelligence, a whole plethora of human expectation and experience is communicated through this eloquent feature. Consequently, once you know or feel that the mouth is in the right place, time spent observing and recording it is rarely time wasted (25).

Adding some Cadmium Red glaze to the cheeks and to the bridge of the nose and some Yellow Ochre, mainly around the forehead and dome of the head, darkens the picture considerably (26).

Even at this very late stage, I am still making changes when drawing into the glaze. The bottom lip, for instance, changes

significantly and the light is renewed across the whole head. That light is then very slightly subdued with some Burnt Sienna glaze down the left-hand side of the painting and small amounts of French Ultramarine Blue, particularly to the lower cheek and jowl on the left side of the painting (27).

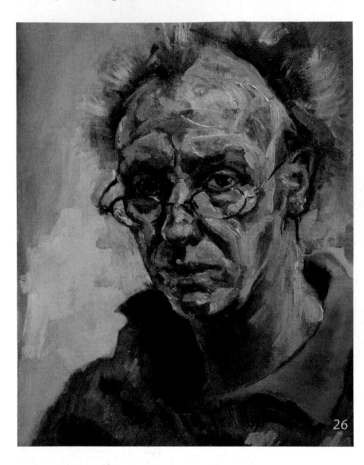

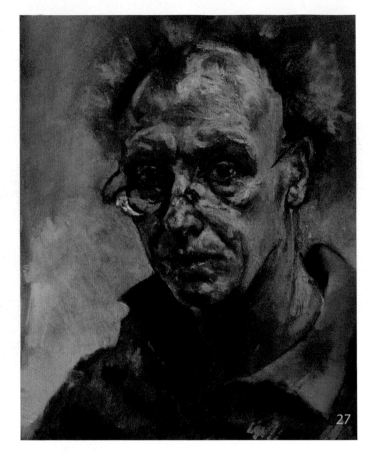

The Finished Painting

A painting should always be incomplete in that it should lead on to the next one; in that sense, painting is not definitive. There will always be other moments, other shifting subjects and different accumulations of paint.

When I made this self-portrait my aim was simply to make the painting work; to find something there that would mark it out as worthwhile. The subject of the painting is a given, I can't

rearrange my face. If I have to describe my approach in the terms already outlined, I think I would say that the painting is rather introspective. A notional, or ideal, an imagined self-image, might easily be tailored by factors over which we have no control; current ideas about how we should be, fashion other people's perceptions – the constraints of 'normality'! More important for a painter, it seems to me, are the realities one finds outside oneself.

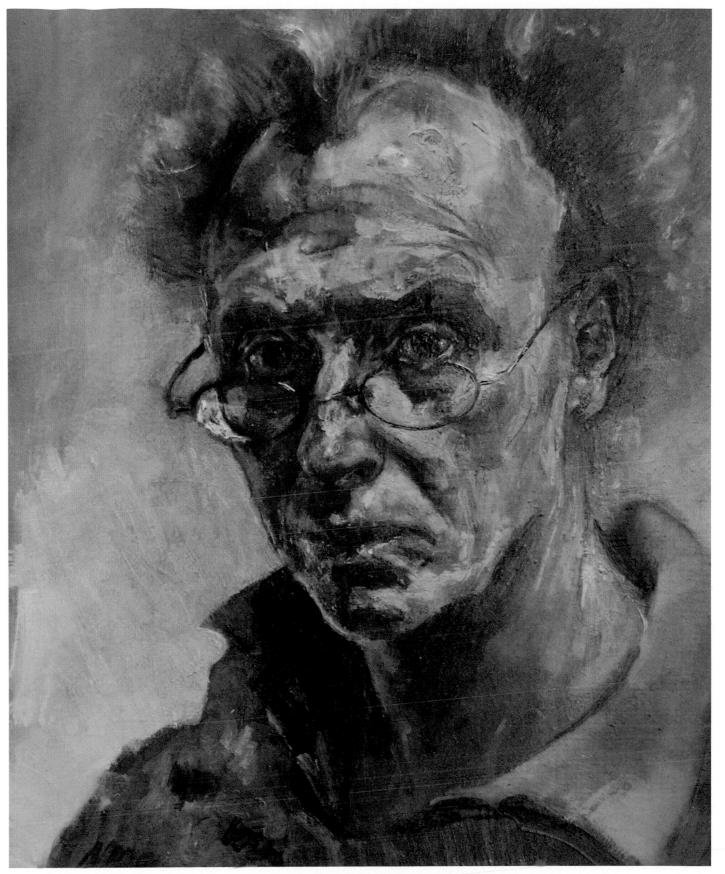

Self-portrait, 2010.

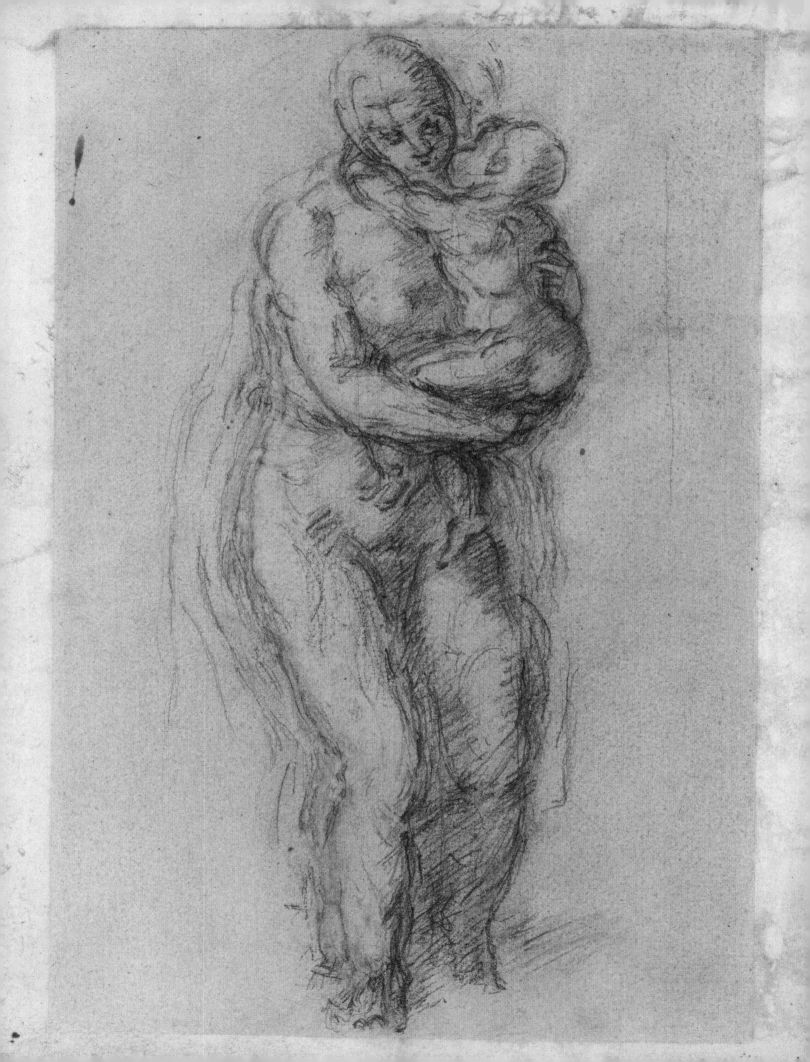

CHAPTER 7

COPYING

The bad artist seems to copy a great deal;
the good one really does.
William Blake

When you look at a painting, there is a total and immediate response; everything is seen, an impression is made. We tend to know very quickly if we are going to like a picture, if it is going to snare our interest. We can certainly make decisions about paintings in the instant that we first see them. It may be that this appreciation is partial, superficial, but there is, nevertheless, something complete about that first appraisal. These initial impressions are not immutable, but they retain value even when we have become much more familiar with the image, and perhaps been persuaded, hopefully by sensitive criticism, of its merits or failings.

Looking at a painting and responding in this urgent, and often cursory, way is essentially an acquisitive activity, a kind of visual shopping. Even when we take time to inspect a painting closely, when we engage with the image in a structured way, we are still consumers, sifting through a display, discarding the unfamiliar, looking twice at items which we vaguely recognize and finally selecting something because of one arbitrary quality or another. We might look at the content, establish what is being depicted and possibly why. We might consider composition and place the picture in an historical and thence in a philosophical context. The picture thus acquires meaning, or, rather, acquires other meanings, for it surely still has the initial 'meaning', that first impression. We might then look at the medium, the way paint is handled. How is colour used? We might consider how this affects the mood and how the intention of the artist is revealed through these formal means. All these techniques will enable us to construct and enrich our appreciation, so much so that our first response might be changed radically.

We are still, however, just refining our criteria for consumption, honing our critical faculties, like amateurs of wine, identifying varieties and vintages, ascribing similes, becoming connoisseurs.

Looking through drawing is an activity of a different order. It is neither acquisitive nor aggressive, but nor is it a passive act. Copying takes you out of the shop and into the factory, even into the eye of the designer or maker. The necessity of responding directly bypasses the constraints of language. It is a response that we construct through a chosen medium, be it pencil, paint or whatever. The medium will probably be the same or similar to that which the artist used. There is nothing to be lost or distorted in translation. When we copy we are obliged, forced, to look closely and to reconstruct that looking in a tangible, visible form. Copying is not interpretation, it is mimicry. To copy is to give an account of one's looking. The account is beyond fudging, beyond dissembling; it is very difficult to lie when you draw. Drawing is a kind of unwitting confession. Like the original from which the copy is drawn, it has to be felt rather than understood. To quote Ingres, '*Je ne puis être senti que par un si petit nombre.*' ('Only a very few are able to appreciate me').

Two things are noteworthy in this quotation. The first is the implication that painting is not a statement to be unpicked or understood intellectually, but to be felt or sensed (*être senti*). The second is the complete fusion of painter and painting; '*Je*' here stands for both the man and his work. Ingres does not differentiate between himself and what he makes. There is no place, no gap, into which an untruth might be squeezed. Copying a drawing by Ingres won't guarantee your illumination, it won't in itself make you an intimate, but it will take you a little closer. It may not transform you into the artist's confidant, but at least you can sit down next to him for a little while. It is a way of feeling an appreciation and of growing that feeling.

LEFT: *Virgin and Child* (between 1550 and 1564); copy by the author of a drawing in the British Museum by Michelangelo Buonarroti (1475–1564). (Michelangelo began his artistic life copying Masaccio. Although I have no evidence to support my fancy, I have always imagined that this very late drawing was also a copy, that in his dotage he had returned to the teachers of his childhood.)

Art colleges used often to be sited next to museums, for example the Royal College of Art was an annexe of the Victoria and Albert Museum, the Ruskin School was in the Ashmolean Museum in Oxford. There was a time, and not so long ago, when this association seemed both necessary and obvious. Students expected to learn through studying great art as well as nature. This model became redundant when history became a nuisance. Rummaging around in the past, treasure hunting, became a questionable activity when society began formally to challenge inherited wisdoms. Marcel Duchamp signed himself 'R. Mutt' on a urinal and Piero Manzoni pronounced, 'being is all that counts'. Manzoni held that everything is art and consequently built an upside-down 'magic base', a plinth which supported the entire world. More quietly, other artists, younger and older, carried on looking.

In 2007, Tate Britain organized an exhibition entitled 'Drawing from Turner'. A group of students and artists were invited to draw directly from drawings by Joseph Mallord William Turner. The aim of this project was to afford this group and, by extension, an interested public, an opportunity to get to know and better understand the 'methods, invention and creativity of a master draughtsman'. The gallery's blurb purposefully avoided the word 'copy', except when qualified by adjectives such as 'slavish'. The participants were asked instead to 'think forensically' about their selected drawing. The subtext was clear, however, that there might be some special value in drawing from or after fine examples; in short, that copying might be worthwhile. Also in 2007, the National Gallery hosted an exhibition of the work of Leon Kossoff entitled 'Drawing from Painting'. The exhibition chronicled one artist's engagement with the work of, amongst others, and in no particular order, Velázquez, Poussin, Rembrandt, Rubens, Veronese, Goya and Cézanne. Kossoff has been drawing and painting 'from' (his preferred description) the gallery's collection all his painting life. He has spoken of the difference between just looking at a painting and experiencing it through drawing. It is as simple as the difference between being outside and being inside. To describe it differently, in an interview with John Tusa, Bridget Riley commented that when an artist makes a copy 'you get very close indeed to how somebody thinks'.

These isolated examples perhaps run against the current of twentieth-century art. But then history often neglects to deliver an entire account. British art has always been somewhat wary of abstraction and has tended to preserve its own tradition of figurative painting. Modernism is, however, undeniably the dominant orthodoxy of the twentieth century, and learning and thinking about art has been shaped by it. Modernism, which is almost a synonym for 'novelty', has promulgated an ideal of abstraction, a vocabulary of imagined forms, of painting totally beyond any reference to the tangible. Copying is the antithesis of such originality. To be modern, to be original, is to explore new territory, to reveal the hitherto unseen. Imitation is not an attribute of Modernism. In this context, the notion that something worthwhile might be achieved by copying is absurd.

Nevertheless, many twentieth-century artists have referenced the past, the craft of previous generations. For some, like Kossoff, one has a sense that it is what compels them. For others, the art of the past is a consumable, like stock on a shelf, items in a catalogue. Stock from which they might, to borrow a phrase from Pablo Picasso, 'steal' whatever serves their purpose.

At the other end of the spectrum from Kossoff, there are artists who refuse to even look at their historical context, at the art of the past. They fear contamination or dilution of a pristine and, possibly, unique vision. Their art has to come from somewhere that has nothing to do with art. Such artists do not want their oeuvre to resemble art at all. Rather, the form has to be dictated by the idea, the concept. Thereby, perhaps, they hope to enlarge the definition of art, or, possibly, even to make redundant any notion of art and its attendant hierarchies. It may also be true, as some commentators have suggested, that the original is always mined with its own destruction, and consciously so. As soon as the unacceptable is accepted, the unknown is made known, the same can be commodified and can become part of 'art', part of the canon. It loses its charm.

Another way of dealing with the canon, of discounting and discrediting what has accumulated in museums, is irony. This is a characteristic of the Post-Modernism of the late twentieth and early twenty-first centuries. Artists such as Glenn Brown, for example, reinterpret paintings, in his case as unctuous, slithering, marbled objects, seemingly made from lurid, sticky syrup. These interpretations are extraordinary to behold, but belong to a satirical, skittish tendency. There is, for example, a snigger, intended or not, in Brown's treatment of Frank Auerbach's painting.

The relationship of the Chapman brothers to the Spanish painter Goya is probably not of the same order. It sometimes seems that the principal theme of work we classify as 'contemporary' is to be scornful about any attempt to transcend a reality which is bleak, carnal and morbid. This can manifest itself in surprising ways, as with the Chapman brothers and their transformations of Goya's etchings. The brothers purchased a complete set of eighty prints by Goya, collectively known as 'The Disasters of War'. They then worked their way through the prints, replacing all the heads of the figures with heads of clowns and puppies. It may be, as Jonathan Jones wrote in The Guardian, that 'The Chapmans have remade Goya's masterpiece for a century which has rediscovered evil.' When Robert Rauschenberg rubbed out a drawing by de Kooning, he did so with the latter's permission. Clearly the Chapmans didn't seek Goya's consent. This lack of regard or courtesy is intentionally shocking. I am less certain as to whether it is justifiably shocking.

There is an illuminating precedent for such vandalism. During the Reformation in the sixteenth century, the painted faces on

church rood screens were hacked off and scratched away. Holes were drilled into depictions of mouths, then plugged with stout wooden plugs. Figures were 'blinded' by gouging out eyes. By exposing the materiality of the painting, by hacking back to the wood itself, the intention was to reveal the illusion.

Other examples of appropriation take us off in different directions. For example, Francis Bacon grafted shards of a screaming head onto his transcription of Velázquez's portrait of Innocent X. It became a shocking metaphor for the post-war condition, an emblem of Modernism. I once saw the original Velázquez in the same room as one of Bacon's versions of the painting. Seeing the two paintings together persuaded me that the truly enthralling and meaningful, the lasting statement, was made by Velázquez and that the Bacon, although still shocking, would always be a slight thing by comparison. It may be that this is not comparing like with like, but I suspect Bacon had a deep regard for Velázquez and, not surprisingly, that he aspired to similar heights. I do not mean that he wanted to paint like Velázquez, but that he wanted, within his own idiom, to achieve something comparable.

I don't know whether Bacon ever saw his work next to the Velázquez, but, certainly, the actual physical comparison of paintings can be revelatory. A truly visceral appreciation requires the real presence. To be felt ('être senti'), the painting itself, not a reproduction, has to be seen. In this connection and by way of illustration, there is a wartime anecdote about Picasso moving his own work into storage at the Louvre. While the lorry was unloading, he took the opportunity to run around the galleries placing his work next to particular classical masterpieces. He would then stand back in order to make an assessment, comparing Picasso to Veronese or to Raphael.

A more useful example for someone who is trying to paint portraits would be a painter like Lucien Freud, who, like Kossoff, makes continuous reference to the work of others, but is more deferential than Francis Bacon. He has curated an exhibition about Constable, has clearly looked at Watteau and has copied Chardin. His work is rooted in the past. His relationship with the history of art is explicit and transparent and of a very different kind to that of Glenn Brown and the Chapmans. There is a sense in which he is attempting to absorb and distil real value for, and into, his own painting. Freud's work is not drenched in irony and although carnal and very immediate, it does belong to, and is indebted to, a living canon. In that sense, Freud's painting is not morbid, and the canon is not moribund.

For a portrait painter then, Velázquez's portrait of Innocent X or Raphael's painting of Baldassare Castiglione are not items to be consumed, they are living fragments of a tradition which obliges us to look and look again. Velázquez, true to Leonardo's dictum, 'he should then copy from some good master', is said to have taken the young Murillo to his own house and to have procured for him the privilege of copying in the great galleries of El Escorial in Madrid. He advised him to copy carefully what he saw there; pictures by Titian, van Dyck and Rubens.

There are practical reasons for copying. You can acquire techniques and learn how a particular painter actually constructed his painting. With some research, you can discover which pigments and oils were favoured and how the paint was applied, although these are not the best arguments for copying. Copying is about acquiring an intimacy. It is a practical way of refining our perceptions. Copying a Holbein drawing for instance, as David Bomberg did, should help you to bare your own antennae when confronted with your sitter. It will raise your expectations of yourself. Copying is a method for shifting one's appreciation from the cerebral to the visceral and of refining that appreciation in the process. Painting exists somewhere within that shift.

The painting overleaf was included in the 1954 Augustus John (1878–1963) exhibition at the Royal Academy. The painter and the priest were brought together through John's son, Henry. Henry John had attended the Jesuit school, Stonyhurst College, where he met Fr Martin D'Arcy, S.J. Fr D'Arcy and the young man became firm friends. Henry described the priest as a paragon and, possibly encouraged by this friendship, he entered the Jesuit noviciate in 1927. He remained in the Society until 1934, when he decided that the Jesuit life was no longer for him. He subsequently met, and probably fell in love with, Olivia Plunkett-Greene. They had planned to spend the end of June 1935 in Cornwall together. Olivia didn't go and wrote to Henry trying to explain her reservations. On 22 June, Henry was seen walking along an isolated stretch of cliffs with his aunt's Irish terrier. His corpse was found on 5 July washed up on the beach at Perranporth.

Augustus John was irreligious and had chided his son for his passionate immersion in Catholicism, urging him to more worldly pursuits. He apparently quipped that it was a shame his son had crawled up out of the Society of Jesus only to tumble down into the sea. Fr D'Arcy doubted that it was suicide, but his father thought differently.

Augustus John's biographer, Michael Holroyd, describes D'Arcy and John as 'the two fathers'. John painted the picture of D'Arcy in 1939, four years after Henry's death. It was painted in gratitude for the care the priest had shown to the painter's child.

Looking closely at the surface of this painting one begins to see quite how worked the paint is. John is a gestural, flamboyant painter and his paintings often have an unrefined quality, with the brushstrokes clearly evident. In this painting, however, the surface has been worked at, overpainted, rubbed back. It is evident that this portrait has not been resolved quickly, but there is still a little frenzy in the paint; the paint is still alive.

I chose to make a copy of this picture, because, at his best, Augustus John painted urgent, incisive portraits that I admire and, perhaps, because this 'pagan saint' of British painting was, as Picasso is reputed to have said, the 'best bad painter' of his time.

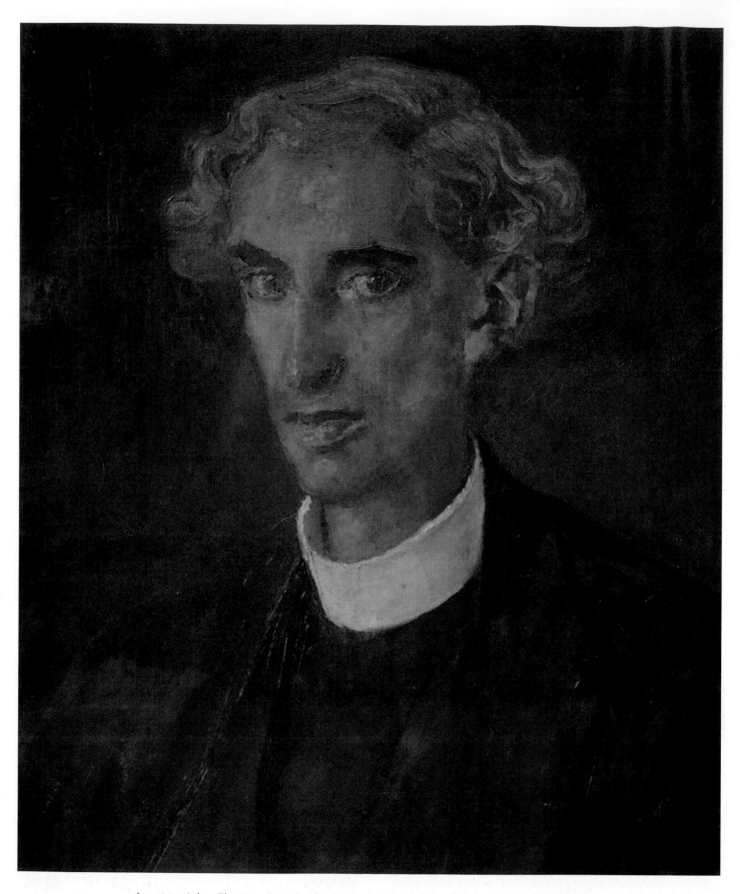

Augustus John, *The Very Rev. Martin C. D'Arcy, S.J., Master of Campion Hall, Oxford,*1939.

The Practicalities

I painted the small study on grey Ingres paper, prepared with gelatine. (The paper is glued onto MDF with a commercial wallpaper paste and, when dry, given a coat of kitchen gelatine. The MDF makes the surface rigid and the gelatine makes the paper less absorbent.) As if beginning a portrait, I start by looking closely at the eyes, trying to locate them in relation to the nose. The resulting triangle, connecting the pupils to the tip of the nose, is particular to each of us (1).

Working out from those initial observations, I begin to grow the face, tentatively trying to find exactly where the mouth might be. This is a fairly direct approach, matching colour as nearly as I can, using my own palette, which will not be the same as John's (2).

It is important continually to check that the features are in the right place. The whole painting should remain fluid; that is, not regarding any portion complete until the whole painting is seen to be complete (3).

It is apparent that the likeness is not yet at all secure (4).

Starting to define the cheek by painting in the background

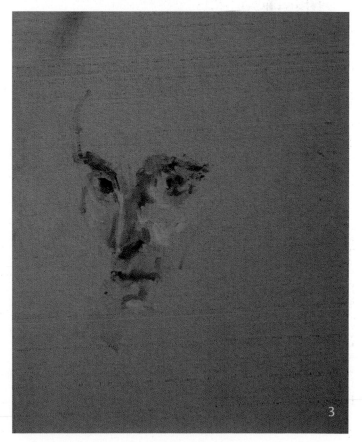

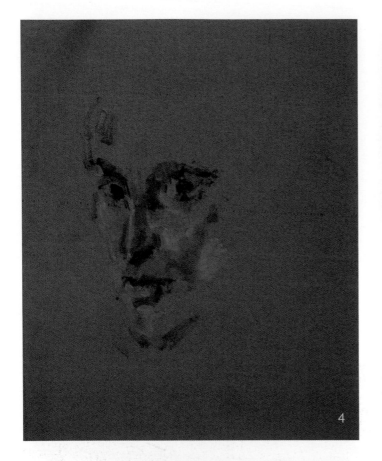

4

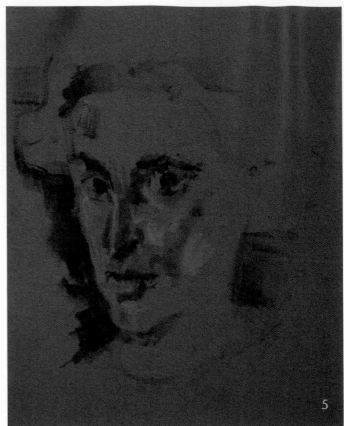

5

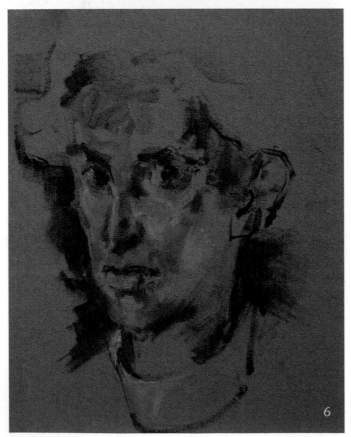

6

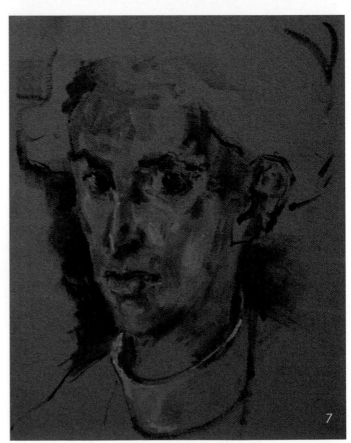

7

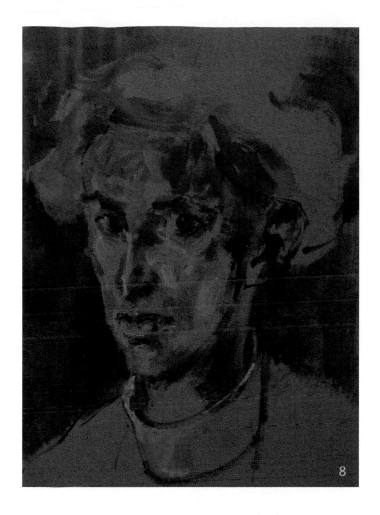

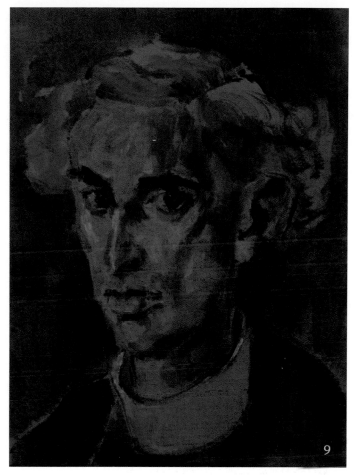

restores something of the likeness, but the drawing is still not quite correct (5).

By defining the placement of the ear and finding the other side of the head, again by painting in the background, the similarity to the original becomes a little more sure (6).

I am now starting to paint in some colour into the forehead and down the side of the face into the ear. Defining the clerical collar contributes to the overall look of the painting, but the actual likeness remains elusive (7).

Next, I look a little more closely at the colour and the way the paint is applied, but the principal concern is still to make the copy look like the original (8).

Still looking very closely at the original, the background is rubbed in and some shadow is introduced down the side of the face, primarily with Burnt Sienna (9).

Looking at the copy and the original side by side, the discrepancies multiply. Being sensitive to these differences is, however, the whole point. In order to establish why the copy differs, one has to look very closely at the original. It is a process of criticism and requires serious attention. One could continue to compare the exact placing of each mark, but at some point it can be quite useful to articulate some of the differences. For example, there is something rather terse and superior about the mouth, but

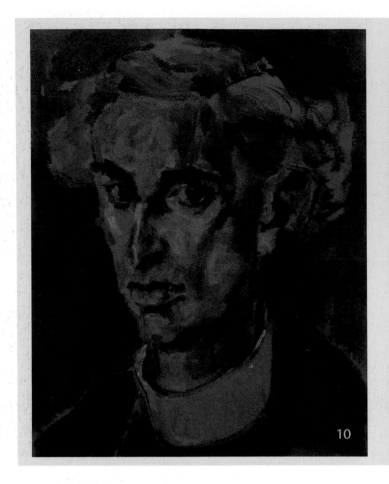

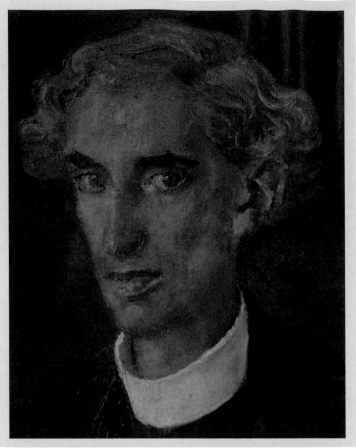

there is also something vulnerable in those large, dark eyes. This is not immediately apparent in the copy. The other very noticeable difference is that of colour. The original is much warmer with more red and yellow in the face (10).

Before looking at the details again, I wash in some Burnt Sienna (11).

After covering the entire surface of the picture with the glaze, I then rub back the new paint in order to soften the overall effect (12).

12

13

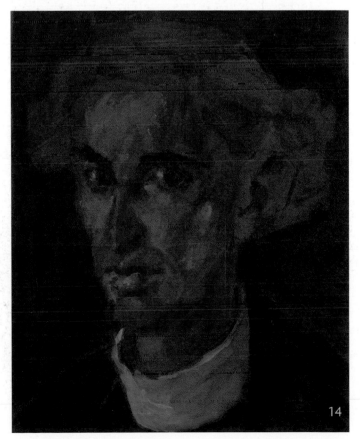

14

Repainting the collar and taking down the background with a thin mix of French Ultramarine Blue and a little Ivory Black restores the tonal relationship of the head to the background and brings the head forward a little (13).

Looking again at the drawing involves reintroducing lights into the face. The lights are mainly made up with Flake White toned down with Yellow Ochre or a little French Ultramarine Blue (14).

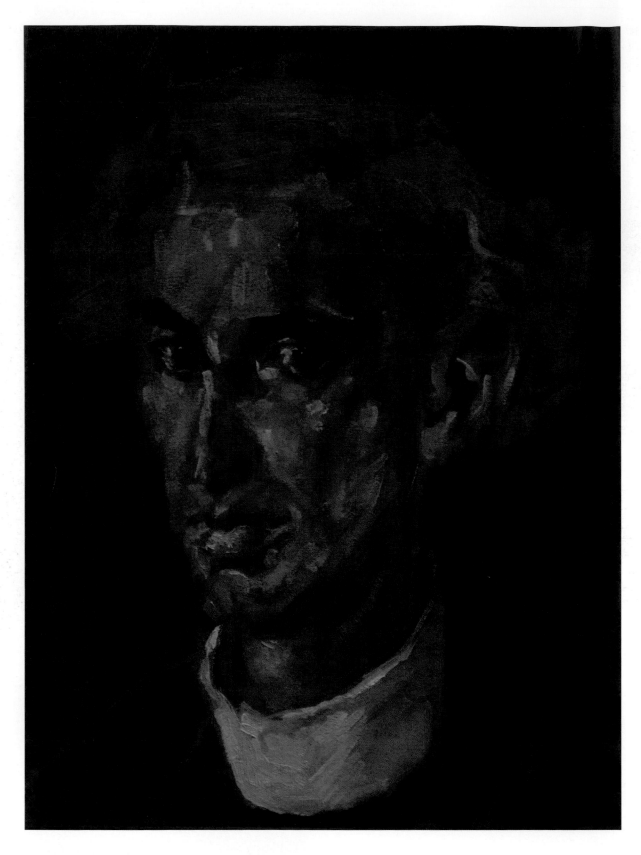

The lips are studied closely again, with the aim of establishing exactly how the copy differs from the original.

The intention is not to produce a fake, but to experience more closely how a painter like Augustus John dealt with paint, the sitter and an expression, and to begin to feel the importance of subtlety. Copying also reinforces the degree of accuracy to which a portrait painter has to aspire in order to reproduce a likeness.

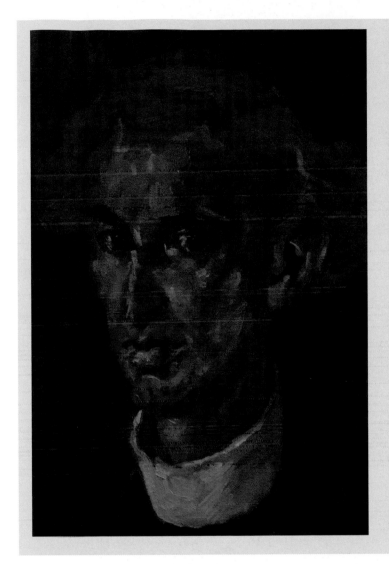

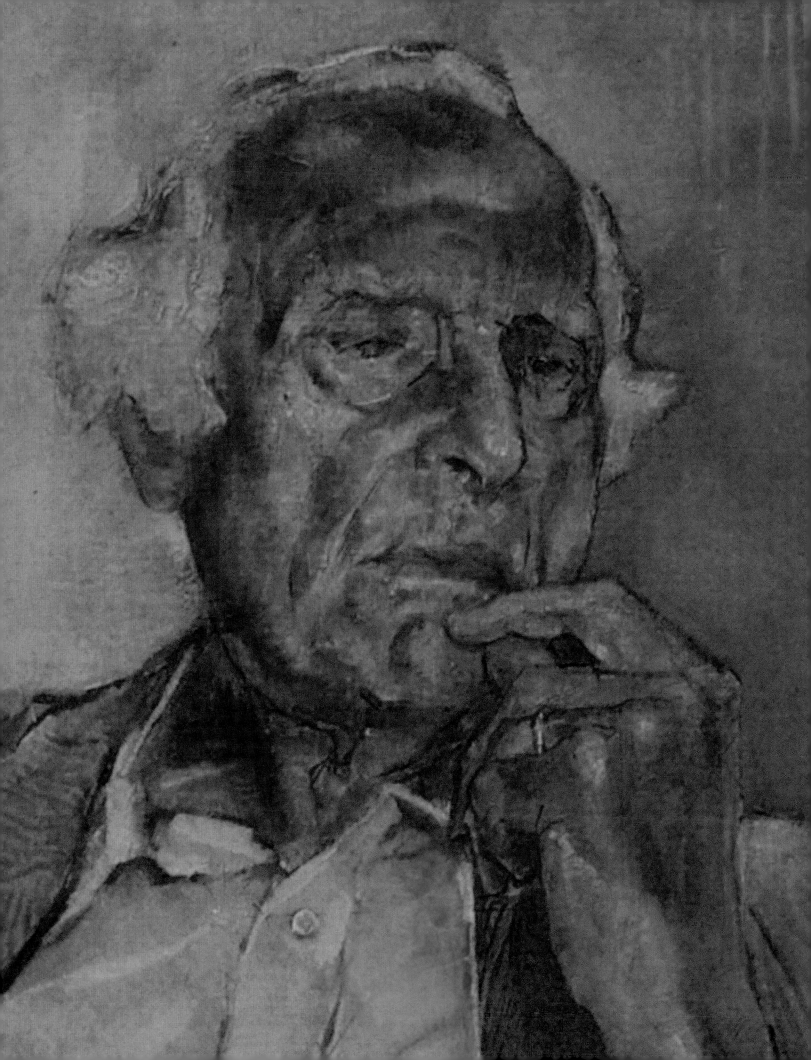

PHOTOGRAPHY AND PORTRAITURE

Photography has nothing to do with portraiture.
Avigdor Arikha

If David Hockney's assertion is correct, and Western painting has been indebted to optical devices since probably the fifteenth century, the advent of photography might be less revolutionary than is sometimes suggested. When it was finally discovered, however, that a likeness could be fixed by means of lenses and chemicals and, eventually, by anyone at all, it was inevitable that photography would displace painting in at least one of its functions, that of reconstructing and representing the visible world.

That displacement, has become a complex mixing of functions. Photography has not actually replaced painting at all, but has been one of the principal causes of the fundamental changes that occurred in painting during the twentieth century. It is more than mere coincidence that the first exhibition of Impressionist painting was held in a photographer's studio. Today, some painters cannot function without photography; to others, photography is the antithesis of their practice.

During the second half of the nineteenth century, painting was broken open, perhaps not entirely by photography, but smashed, nevertheless, into its constituent parts. The subsequent history of Modernism and painting might be seen as a series of attempts to put those parts back together; to form coherence out of disorder, meaning out of disarray and confusion. In this context, the frequently heralded 'death of painting' becomes some kind of commentary on these attempts at resuscitation.

The advent of photography helped to ease painting into quite different intellectual and perceptual territories. The subject matter, the thing pictured, was separated from the stuff of the picture, the object, the paint itself. When Cézanne painted an apple, he did not try to deceive the viewer's mind by creating an illusion. His paint looks like paint. The means of making the depiction, the pigment and the brushstrokes, retain their inherent qualities. The pictured and the paint are balanced, as if they are two halves of an equation; both can be seen, both are of equal consequence. Painting moved beyond or, at least, alongside, illusion. Zeuxis deceived the birds when he painted a bunch of grapes, but when Parrhasius deceived Zeuxis by painting a curtain, he was hailed as the greater of the two. Neither Zeuxis nor Parrhasius, however, had to compete with photography. Painters came to realize that the ability to create an illusion was no longer sufficient. Something else was expected of painting, if it were to continue to be considered a serious form.

For other painters, the subject, the picture, became entirely subordinate to the object, the paint. The subject became the object, that is, the painting came to be about the paint and the canvas. Abstraction, pure painting, became a reality. For an abstract painter, the very notion of creating a picture, an illusion, would seem irrelevant, even dishonest.

Painting also came to be about other things, not just itself; it no longer had to evoke a semblance of the visual world, it could be symbolic, expressive, surreal. Van Gogh experienced and expressed his reality in paint, not illusion. Munch sought to be true to his sensations. Kandinsky painted what he heard. O'Keeffe made painting about a headache. Gerhard Richter has made paintings about photographs, that is, not about the objects pictured in the photographs, but about what photographs themselves might be. The traditions or genres of history painting, still life and portraiture became, if not redundant, then at the least rather outmoded classifications.

The different activities that the term 'painting' has eventually come to describe range from the construction of minimal blank canvases, sometimes displayed face to the wall, to pictures that are indistinguishable from the photographs used to make them, some even heightening the photographic illusion.

Portraiture (outmoded but persistent) declined in importance during this period. It mirrored this larger activity called

LEFT: *Kyril Zinoviev*, 2009.

painting, coming to be more about painting itself than about sitters. Certainly during the twentieth century it has not greatly interested the more ambitious painters (notable recent exceptions include Chuck Close, Francis Bacon and Andy Warhol, all of whose work is drenched in photography). Latterly, however, there has been something of a revival of interest in portraiture. Institutions such as the National Portrait Gallery and the Royal Society of Portrait Painters have always continued to promote portraiture and now gifted young figurative painters are making portraits, finding receptive audiences and a degree of critical appreciation.

Portraiture now ranges from the photographic to the abstract; from the luridly 'real' paintings of Fred Schley or David Eichenberg to the *Portrait of Mr and Mrs E.J.P.*,1969–1973, by Howard Hodgkin, a painting that simply gives no visual clue at all as to the identity of the 'sitters'. The majority of portraiture is necessarily, however, still more concerned with the subject than the object. It has more to do with the recognition of a face than with the communication of an emotion or an idea. The person depicted is of more interest than the stuff used to make the painting. That is not to say that portrait painters are not very concerned with the means of creating a picture, but that, in the vast majority of cases, some likeness of the sitter will eventually emerge from the paint.

While, of course, many photographers (and some artists who express themselves primarily in paint) take almost endless pains to compose a photograph, shifting all the possible variables, all the elements of the final image, the camera itself does not discriminate. Photography, like any technology, has its limitations. It gives a 'photographic' quality to an image. Amongst the great photographers are those who expand our perception of that quality. Typically, however, when we look through a lens we tend to site the principal object of our attention somewhere in the middle of the frame. The camera then gathers in all the surrounding paraphernalia and cuts an uncompromising line clean through it. The incidental is not edited out, the consequential is not always made prominent. A photographic composition, if composition is the correct word, can have a random, serendipitous quality to it. Painters will make paintings about what they find in such photographs. Often it is the unusual or unlooked-for in photographs that will provoke a painter. Painters make creative use of photographs by editing and juxtaposing fragments, en route to the composition of a painting.

Edgar Degas made beautiful and new designs precisely because he knew about and used photography. Pierre Bonnard, too, painted flattened-out interiors filled with the bric-a-brac found at the edges of photographs. Walter Sickert used photographs to construct his bleak and murky glimpses into domestic dreariness (and worse). The actual presence of a sitter, Sickert claimed, was unnecessary. He would simply take a series of photographs from a variety of angles, then make his painting using those as his source material. The random quality of the photography stimulated his interest in composition and allowed him a certain freedom in his handling of paint. Study of Picasso's own collection of photographs has revealed that his Blue and Rose periods may owe a great deal to the blue tint of cyanotype prints. Painters like Jenny Saville use technology to manipulate photographs, in order to find alarming or unlikely flavours and combinations. Michael Andrews painted enormous, uneasy, studies of photographed scenarios, such as *Me and Melanie, Swimming*, 1978–9.

> But o, photography! As no art is,
> Faithful and disappointing!
> *from 'Lines on a Young Lady's Photograph Album'*
> *by Philip Larkin*

A photographer aims and shoots. The photograph is taken; a moment is captured. It is something of a cliché to trace photography's predatory characteristics through the associated vocabulary, but there is, nevertheless, something subtly aggressive about the act of taking a photograph. Susan Sontag in her essay 'In Plato's Cave' writes that, 'to photograph someone is a sublimated murder – a soft murder'. The loss, the death, lies in part in the reduction of a presence – felt, sensed, heard, touched, experienced – to a purely visual, totally detached, manifestation.

Less drastic, but in some ways more disturbing, Diane Arbus comments on the shadier, more voyeuristic propensities of photography, 'I always thought of photography as a naughty thing to do – that was one of my favourite things about it.'

Wherever the painter sources his subject, that source will, when incorporated by whatever means into a painting, create unintended consequences. It is for this reason that it is worth reflecting upon the inherent qualities and characteristics of photography, as these qualities will inevitably emerge in the painting, in some guise.

Portrait painters who paint from life but use photography as part of their process have noted the change in the sitter's demeanour when a camera is produced. The sitter is suddenly alert, their whole posture changes and stiffens. Of course, the sitter will then relax and become more 'natural'. One can become inured to the presence of a lens; the television programme Big Brother may have illustrated this point, or, then again, perhaps not. Our initial response to a camera is different from our response to another person, even when that person stares at us, paintbrush in hand, for hours at a time.

The camera may be intrusive, but it is also detached. It does not interpret, it simply discloses with constant accuracy exactly what hits the film or the sensor, through the lens. While professionals may warm to the camera, the camera remains cool – it would be a mistake to anthropomorphize the apparatus in any way. The relationship, if it exists, is with the photographer,

through the camera. The camera does what it does; it homogenizes the visible world.

If photography is aggressive, intrusive and reductive, why then do painters, and portrait painters in particular, resort so readily to this medium? Firstly, some likeness to the sitter is generally regarded as crucial if a portrait is to be a portrait, but the achieving of this likeness can be very elusive. The geometry of the face is extremely subtle – slightly misplacing the mouth, or extending the forehead a little too much, can completely distort a face. Photography enables the painter to establish a likeness very securely. The photograph is a precision document.

Secondly, drawing or painting from life is a hugely complex undertaking. One has to clarify the massive confusion of the real world, to transform a three-dimensional puzzle into a two-dimensional description of that puzzle. That process of reducing three dimensions to two, while retaining a semblance of the third, is complicated. Photography is a reductive agent, performing this task for the painter.

> In the fairy tale of photography the magic box insures
> veracity and banishes error, compensates for
> inexperience and rewards innocence.
>
> *Susan Sontag, Melancholy Objects*

It is undeniably the case that some painters, such as Sickert, actually find the presence of a sitter a distraction. They require the visual resource or stimulus that the photograph provides, but also the privacy and solitude in which to explore that material. The very still occupation of painting from a photograph can be quite mesmerizing, a kind of meditation. Photography can also bring a certain rigour and exactitude to the task. A painter won't necessarily be able to rely on his limited repertoire of forms, because the photograph, true to 'the impregnable without' (Samuel Beckett), might require the painter to depart from his preconceptions. The photograph might oblige consideration of the unimagined just because the unimagined appears, true and clear, there in the photograph. For some painters, this can be a source of visual delight. Photography then becomes an agent of renewal and revelation. Certainly some fine painting is unimaginable without photography. Photography can be a stimulus, a point from which to embark on the adventure of painting.

There are also painters, inevitably perhaps, who eschew photography. Some believe that the ubiquity of photographic imagery has tainted our collective perception of reality; that pointing a camera at the world has become something we do instead of looking. They feel that the only way to see clearly, truthfully, is to rely on their own vision.

The wonderful Israeli painter, Avigdor Arikha, said of one of his heroes, Diego Velázquez, that 'he understood the importance of painting from life, because he probably had the intuition that, in painting from life, he drew the energy which made his painting hold that breath of life ... [The painting of Velázquez] is the breath of life, captured by the brushstroke, and held within pigment.' For such a painter, photography is an irrelevance. It is irrelevant because to hold that breath, you have to breathe the same air, you have to be there with your subject. He simply would not be able to draw that breath from a photograph.

There are considerations then, choices to be made. Perhaps Man Ray's approach was the most practical: 'I photograph what I do not wish to paint and I paint what I cannot photograph.'

The Practicalities

There are several ways of accurately transcribing a photograph. It could be projected directly onto the canvas, traced, or transferred using a grid system, which is the method I have chosen. For simplicity's sake, I have contained the grid within a square, rather than a rectangle. This means that I need only make one measurement, that is, one side of the square.

I have chosen to use this photograph of a young girl. She is eight years old. Although she is looking straight out of the frame,

she is not looking directly into the camera, but slightly above and beyond. I find this slightly 'away stare' quite intriguing.

This shows the grid drawn out onto a copy of the photograph. The process is simple – using a set square and ruler, a square is carefully drawn with a sharp pencil or fine pen around the outside of the head. Diagonals are then drawn, from corner to corner, within this square. Horizontal and vertical lines are then drawn through the intersection. The original square has now been quartered. Again, diagonal lines are drawn in each of these new squares and once again each square is divided into four more squares (1).

It is important to be as accurate as possible, so it is necessary again to use a set-square, a sharp pencil or fine pen and a good ruler. If using pencil, it should be sharp but soft, so as not to score too deeply into the surface of the paper (2).

The outline of the face and principal features are drawn in as accurately as possible. A 2B pencil, well sharpened, will allow me to be accurate while not scoring into the paper too deeply (3).

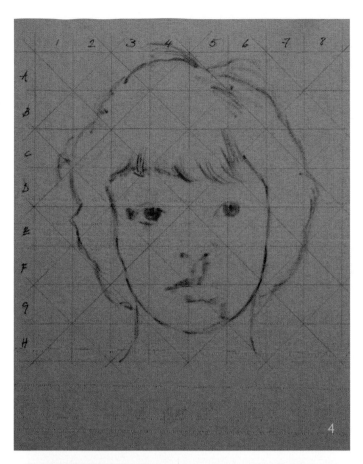

The ground is grey Ingres paper, pasted with commercial wall-paper paste onto MDF and then coated with kitchen gelatine. The drawing is reinforced with some Burnt Sienna (4).

The shape of the head is clarified by roughing in some Flake White, which is also used on the face in two tints, one with Yellow Ochre and the other with Cadmium Red (5).

The hair is underpainted with Ultramarine Blue, while continuing to colour the face with the tinted whites (6).

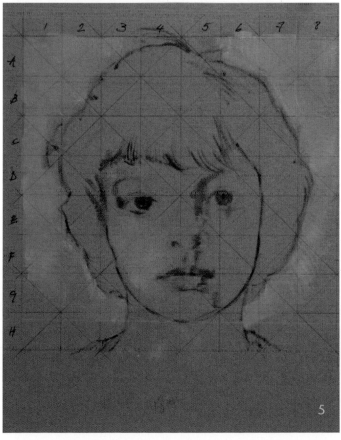

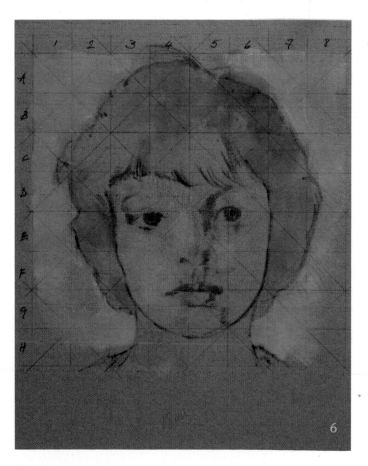

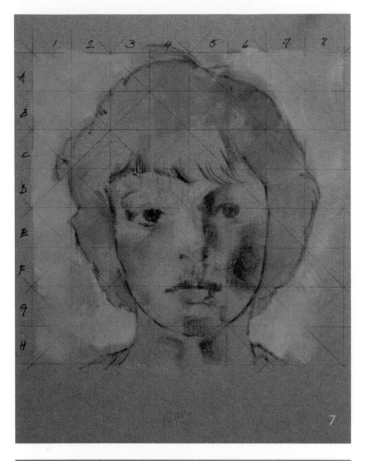

7

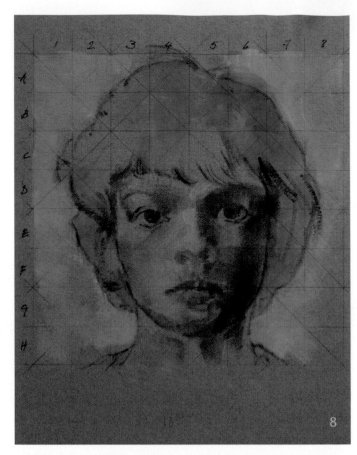

8

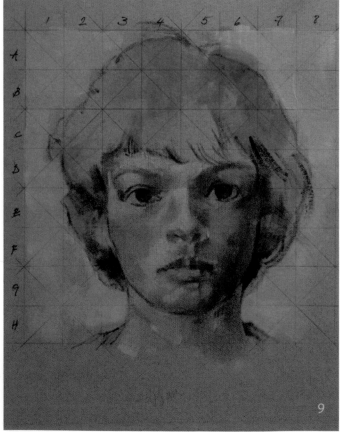

9

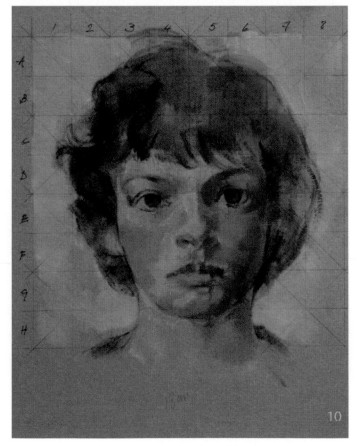

10

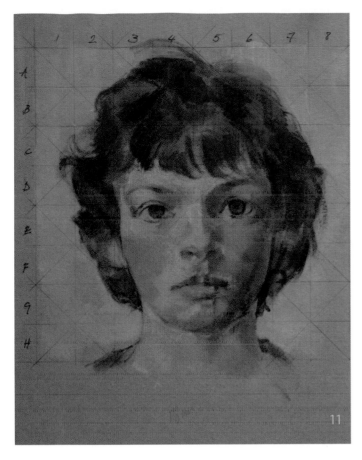

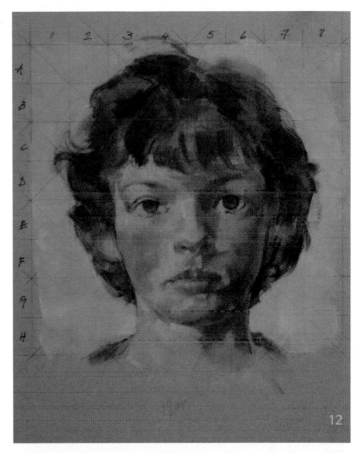

The shadows are warmed with Cadmium Red and Burnt Sienna, brushed in rather dryly and in quite an approximate fashion (7).

The shadows are extended using Raw Umber (8).

By painting into the red and brown with some white, the shadows are lightened and some of the softness in the face is suggested (9).

The hair is worked into with some Raw Umber (10).

The face is now enclosed within a dark bonnet of hair and is ready to be painted into again (11).

Colouring the shadows with Cadmium Red and Burnt Sienna, I then begin to look quite closely at the lips (12).

The shadows are painted into again with the tinted whites (13).

Looking much more closely at the eyes and mouth, it seems to

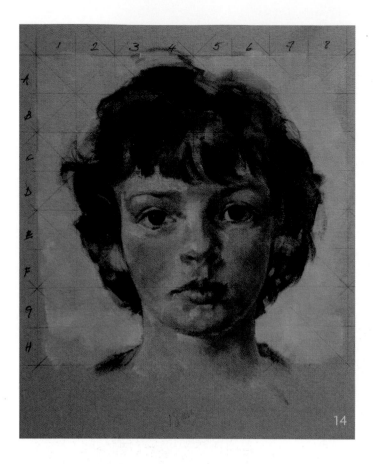

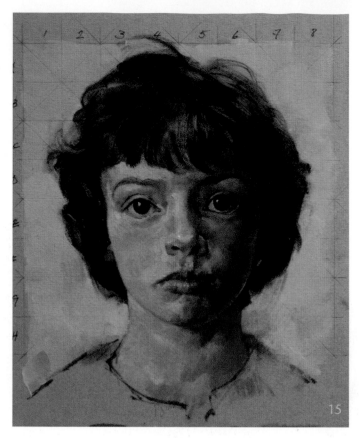

me that the eyes are rather staring straight at the viewer, which doesn't exactly correspond with the original photograph (14).

The painting of the hair is further refined with some strong browns and blue-grey highlights. The line of the jaw is defined and some changes made to the eyes and mouth (15).

The final state is not really that, in as much as one could continue to refine the painting. Some slight changes have been

made for instance to the upper lip and to the shadows under the eyes.

In sum, painting from a photograph in this way does provide the opportunity to play with the image, strengthening certain tones or colours, perhaps distorting the face slightly in pursuit of some nuance that better expresses the painter's 'feeling' for the subject. Throughout this process, the painter can know that there is a sure base, that of the photographic template.

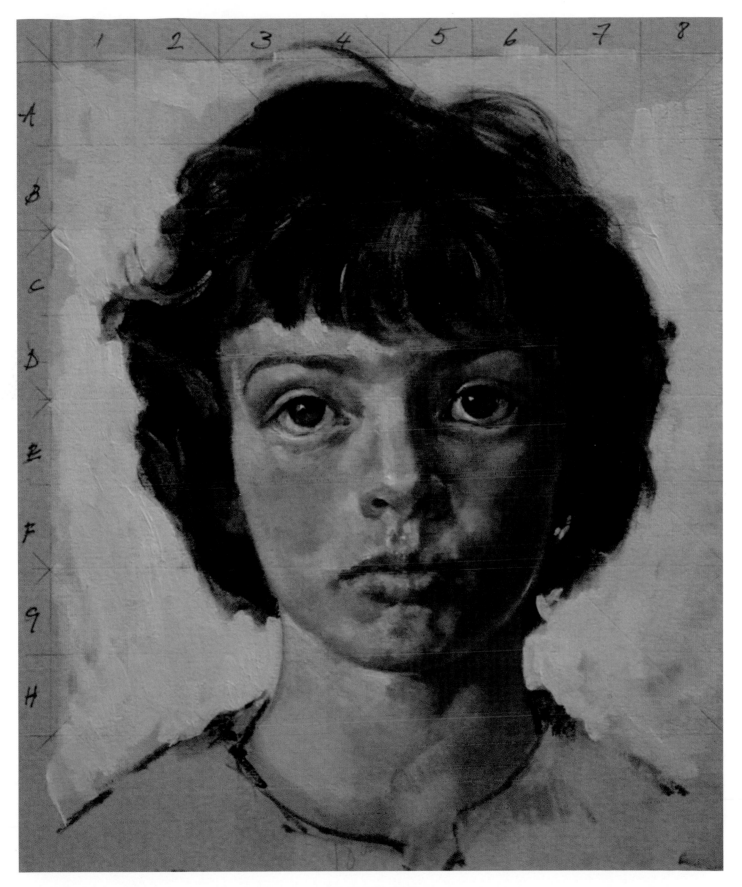

Annunziata, 2010

SOME PORTRAIT PAINTERS

I began my research for this chapter by talking to other artists. All the painters I approached shared one characteristic; that they weren't terribly interested in the work of other contemporary portrait painters. They sometimes expressed a passing interest in the work of one or other of their peers, but it was never an interest that approached a desire to emulate. This lack of enthusiasm, in some cases, was founded on an informed familiarity with the contemporary scene, while elsewhere it was a lack of interest produced by a kind of insouciance. It was very clear that what motivates them is their own work and its relationship to an agenda that they have explicitly or tacitly set for themselves.

David Sylvester, arguably one of the most important critics of the twentieth century, referred to this phenomenon with regard to Francis Bacon. He said that Bacon was pretty scornful about most artists and especially Jackson Pollock (whom incidentally Sylvester regarded as a much greater painter than Bacon). Bacon, according to Sylvester, had this trait in common with Alberto Giacometti, who similarly found very little contemporary art pleasing. He contrasted this attitude to that of another luminary of the twentieth century, Willem de Kooning, who was apparently much more generous about his fellow daubers. My experience so far is that the Bacon/Giacometti model is the norm; I have yet to come across a painter like de Kooning, who was genuinely enthralled with the work of his fellow searchers. This is perhaps not surprising when considering portrait painters. A portrait is a celebration of an individual by an individual. In Orhan Pamuk's novel, *My Name Is Red*, the murderer, who is a painter himself, refers to Christian portraits as idolatrous, transforming likenesses into objects of worship. The novel begins in 1591, in Istanbul, and the murderer is working in a painterly tradition that suppressed individual style or expression in favour of conformity; emulation of the masters was valued above all else. Young apprentices were delivered to workshops, which, under the guidance of such a master, pro-

vided a painful and rigorous formation. Such a regime is the antithesis of the contemporary situation. Portrait painters today tend to be self-taught, even if they have had an art school education. Contemporary portraiture celebrates the individual, both painter and painted. Originality, not imitation, is valued. So, perhaps, painters who now express little interest in the work of their peers are simply painters of their time.

It would be very misleading, however, to imagine that the portraitist does not have some sense of his own work within an historical context. All the painters I talked to enthused about dead painters; even recently deceased painters qualified for approbation. This perhaps suggests that what the painter is really enthused about is the prospect of some clear ground into which he can grow his own painting; new territory, unsullied by and preferably unknown to his contemporaries. The archive, the canon, of great painting provides benchmarks against which the painter can measure his or her own achievement. It may be that the work of one's peers is just too mercurial, too live, too close, to allow dispassionate judgments to be made. It is easier to assess a painting within the context of an artist's complete output. The complete output of one's living contemporaries is obviously not complete at all, and hence is unknowable. Distance, once again, is looked for, to refine and inform sound judgment.

Another common trait amongst the painters I talked to was their capacity to immerse themselves completely in the act of painting; simply, their sheer enthusiasm for their art. They all gave the impression that making a painting could be totally and exclusively absorbing. I had little sense that these painters had made career choices, just that they had found themselves more and more doing the thing that is, for them, totally distracting. I felt that often they had constructed their careers around something they simply couldn't help themselves from doing.

LEFT: John Bulloch Souter, *Self-Portrait*, 1930.

Alastair Adams

Alastair Adams is a portrait painter whose work is distinguished by the wealth and complexity of the narrative contexts in which he finds his subjects. His formal portraits picture a feast of objects; the paraphernalia that settles around particular individuals or couples. That his sitters belong with these objects is apparent, no doubt because Adams invests considerable time in getting to know his subjects. He may not make any marks on a surface at all during the first 'sitting'. He takes a large number of photographs and sometimes uses that information to begin a discussion with his client as to how the portrait might evolve. The acquaintance and the visual record, both painted and photographed, provide Adams with material upon which he reflects and with which he constructs ideas and proposals.

The paintings are, at one level, solutions to design problems, but the problems do not remain static; the whole process is organic. For instance, Adams paints on a surface that is larger than the intended final outcome. This allows him to 'bleed' out from the original conception, if the painting requires it. While the paintings are, perhaps, more consciously designed, less

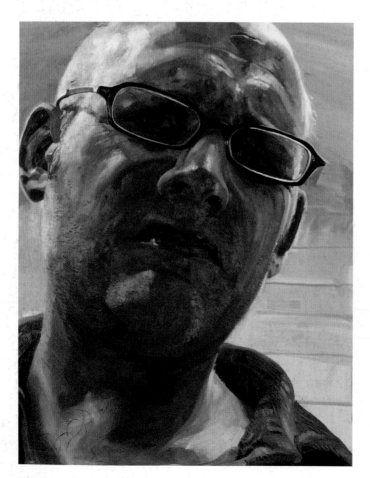

Alastair Adams, *Self-Portrait*.

fluid, than is the case with some other painters, the ongoing dialogue between painter and painting is just as important. These paintings are testaments to the empathy between painter and subject, because Adams wants to know his subjects and because he is sensitive to what the developing picture has to tell him about his sitters. It is clear when you look at these paintings that there is a relationship, a warmth, that the sitters are not simply objects observed, but are partners in the project. Interestingly, in both of these double portraits, the painter has included his own reflection; quietly, unobtrusively, he completes the equation.

Adams is a painstaking and thoughtful painter. He tends to make much of the painting in his studio, away from the sitters. That time away seems to be important to some painters. It can be a time of reflection but also of experimentation both necessary activities that can happen, for some portrait painters, more effectively without the constant presence of the subject.

Adams paints on MDF primed with a clear acrylic canvas primer. He seals the board to inhibit gassing, or the leaching of formaldehyde from the substrate into the painting. In conversation, it quickly becomes apparent that he has thought a lot about the whole process of making portraits, both technically and psychologically. He is as much at ease discussing the chemistry of formaldehyde and its use as a binder in low-gassing medium-density fibreboard, as he is explaining proxemics. (Proxemics is the study of the effects of the physical distance between people in different cultures and societies, of unintentional reactions to sensory fluctuations, such as subtle changes in the sound and pitch of a person's voice.)

His palette is not overly complex and is based on complementary colours. He has hot and cold yellows and reds, Phthalo Blue, and some supplementary secondaries – Cadmium Orange, Dioxazine Purple and Phthalo Green. He uses Titanium White but no black.

There are different ways to separate and describe painters. Adams is very articulate about his business. He compares his approach to the ethnographer's discipline. He aims to be in a comparable situation, observing without intruding. When Howard Hodgkin, by comparison, paints Brigid Segrave, the painting is unequivocally about painting. The subject may be an important component, but what we see is a painting by Howard Hodgkin. Hodgkin was presumably guided by an experience and his memories of it when making this painting. The painting might depict a figure holding a mirror in which a reflected image of the figure appears, but it is difficult to be certain. This work may succeed as an abstract motif, but with more difficulty as a representational painting. When you look at a painting by Alastair Adams you are welcomed into the time and space that surround his sitters. Perhaps Hodgkin is an extreme example, but if you look at another contemporary painter,

Lucien Freud, I think it is equally true to say that it is immediately evident you are looking at a Freud painting; the subject becomes secondary. This cannot be said of an Adams painting. He manages the balancing act between paint and picture with sureness and elegance.

The wash of cool green that lights Mr and Mrs Birch creates air and space within an otherwise rather crowded image. There is a degree of symmetry in the design, but the interest and the tautness derive from the subtle departures from that symmetry; the red candles and the glass lampshades on either side of the mirror, for instance. In much the same way, a likeness, that which differentiates us one from another, derives from this play of symmetries and asymmetries. The slight asymmetry of the design is rather like the asymmetry of a face itself. So, perhaps, to play with the conceit a little, it might be that the whole painting not only includes portraits but is itself a likeness; a likeness of the place and the moment.

The actual story of this painting and the significance of the objects are probably only known to those involved, but there is so much here which does seem relevant. That relevance must in part derive from the effective design of the picture. The painter is himself alluded to by the reflection of the easel, but only appears as a likeness at one further remove; a picture reflected in a mirror. There is something diffident about the way Adams withdraws his own image from the picture, putting himself in the background of the background.

Alastair Adams, *Mr and Mrs Birch*, 2004.

Again, one is immediately drawn to the composition of Fritz and Ingrid Spiegl; the music stands enclose the sitters. The stands are not identical and they both seem rather special and treasured. The organ is a kind of visual fanfare in the background, echoed through reflection in the foreground. The silver teapot delicately centres the eye and almost imperceptibly introduces the painter. The sitters do not look directly out at the viewer; rather, Fritz Spiegl gazes off into the middle distance, while Ingrid casts an affectionate regard on him. He emerges, illuminated, from the shadow, while she recedes a little against the lighter background. The sitters relax in the soft centre of the painting. Only the cat notes the viewer and the painter's presence. This very musical painting is scored with real delicacy, a subtle game of complements and counterpoint.

Alastair Adams, *Fritz and Ingrid Spiegl*, 2004.

Andrew Festing

Andrew Festing paints from life, mostly. If you were to have your portrait painted by him, you would be expected to arrive at his studio on a Monday morning at 9.30am. You would then spend some time discussing the pose, the costume and the size of your painting. Decisions would be made and the primed linen would be stretched then and there to the agreed dimensions. Festing then lays a thin acrylic ground on the canvas, made up of Burnt Sienna, Zinc White and a little Cobalt Blue. He uses acrylic to colour the ground because it dries very quickly.

The rest of Monday is given to drawing. He uses a very fine sable brush, some Burnt Umber and turpentine. He measures endlessly and finds callipers indispensable. On Tuesday he paints the head.

His palette is rich with earth colours; Burnt and Raw Sienna, Burnt and Raw Umber, Van Dyck Brown, Cadmium Red, Naples Yellow, Cobalt Blue, French Ultramarine, Charcoal Grey, Paynes

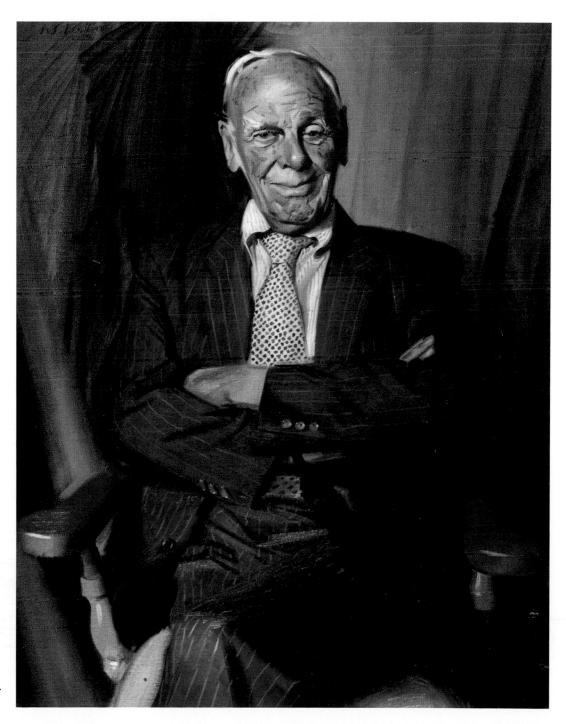

Andrew Festing, *Lord Deedes*.

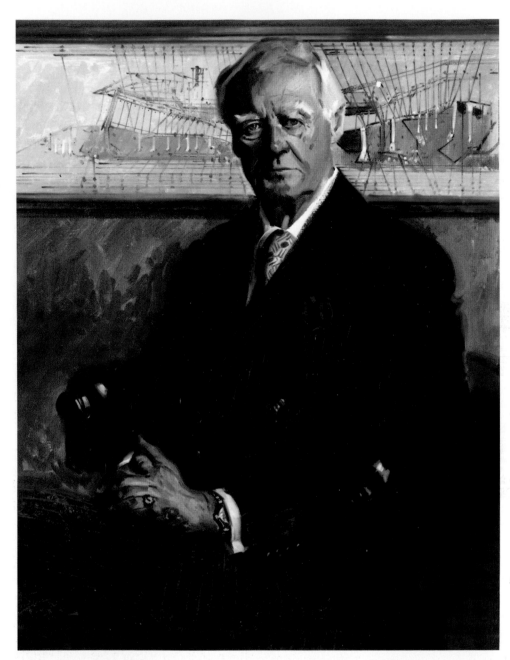

Andrew Festing, *Sir Ralph Robins*.

Grey, Ivory Black and recently, Zinc White. There are other colours, such as Magenta, which he might add in to this collection, but this is his basic palette. He is interesting about colour and will tell you, for instance, which Umber to use for warm shadows and which for cold. His current choice of Zinc as his chosen white, is a choice made through working with other whites, and reflecting upon their different qualities. Perhaps because Andrew Festing is an autodidact he seems to construct his practice on first principles. One has a real sense that his authority derives from experience.

He rarely goes over a finished area of a painting, he doesn't over-paint. He never uses glazes. At the end of Tuesday he would expect the head to be complete.

On Wednesday he paints the body, usually not the hands, which he leaves for Thursday.

Friday is a finishing-off day. I imagine this to be time spent attending to all those details which remain unresolved. By Friday afternoon the painting would be finished.

Andrew Festing is self-taught, although working in the picture department at Sotheby's for thirteen years definitely informed his eye. He specialised in the grand 18th c. English painters such as Lawrence, and Gainsborough but he also has a high regard for the portraitists of the first half of the 20th c., painters like John, Orpen and McEvoy. He also remarked to me, as have other painters committed to painting from life, that he feels one either can or can't draw. He doesn't seem particularly

enthralled by the work of other contemporary painters but qualifies this by adding that he is equally critical about his own work. He has described his attitude to his own work as ambivalent.

His perfect sitter would be an old man, cadaverous, with black bushy eyebrows, ugly and interesting, preferably scowling. At the other end of the spectrum a pretty, smiling eight-year old Scandinavian girl with blond hair and blue eyes would be a tremendously difficult and challenging subject to paint.

Festing's approach to painting is sublimely unfussy and pragmatic. He always lets his sitter see the painting as it progresses. He paints every day and he paints a lot of paintings. Someone once remarked to him that a painter should paint large numbers of pictures. The more prolific a painter is the more chance he has producing something good.

If he has to use photography he will but thinks it important to continue to paint from life as much as possible.

Bill Deedes, Baron Deedes of Aldington, was a soldier, a journalist, and a politician. He was a close friend of the Thatchers and according to some sources, he was the journalist used by Evelyn Waugh as the inspiration for the hapless William Boot, protagonist of the satirical novel Scoop.

He is here depicted looking directly at the viewer. His sense of humour and self-assurance are evident. The large tie and slightly unkempt look are the attributes of a large character. His charm has been sensitively captured by the painter. It Is worth noting that the head would have been painted in just one day.

Sir Ralph Robins was the CEO of Rolls-Royce. He served twenty years on the board of Rolls Royce, retiring in 2003 after ten years as chairman.

The rather vivid blue presence of the figure distracts the eye somewhat and doesn't really prepare you for the equally blue inquisition of the eyes. The head is cleverly set off against the diagram behind the sitter. The whole composition suggests a compelling, even perhaps, uncompromising character. The strong horizontal lines reinforce this impression.

Andrew James

Andrew James paints large, demonstrative paintings. He uses closely woven, fairly heavy cotton duck, primed with acrylic gesso. His palette consists of Cadmium Yellow, Yellow Ochre and Yellow Lake, Cadmium Orange, Cadmium Red and Alizarin Crimson, French Ultramarine, Viridian, Prussian Blue and Prussian Green, Burnt Umber and Payne's Grey. He uses Titanium White, but no black. He describes his choice of palette as instinctive.

I think it fair to say that James' approach to portraiture has to do primarily with paint and especially with colour. He often works from photographs and I suspect this is partly because the

presence of a sitter would distract from his dialogue with the painting, the real intimacy for James being that of the painter and his palette. That is not at all to say that James' portraits are not sensitive responses to his sitters; quite the contrary. It is just that he reflects on his appreciation of his sitter by working it out in paint. He responds to the photographic image in a way that makes you feel that the photograph has provoked him and not restricted or defined the painting. Photorealism heightens the experience or effect of a photograph, often with disquieting results; by contrast, James heightens the experience of colour, occasionally causes alarm, but more often and certainly in the examples illustrated, affirms our shared humanity.

If James has a dogma or manifesto, it is practical, tangible and visible. It is articulated most succinctly and coherently in paint. Interestingly, he does not worry unduly about the likeness and in contrast to some portrait painters does not need to establish a sure likeness during the early part of the process, preferring sometimes to defer that commitment until quite late in the

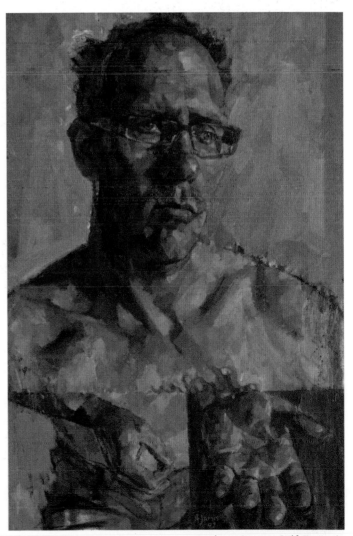

Andrew James, *Self-Portrait*.

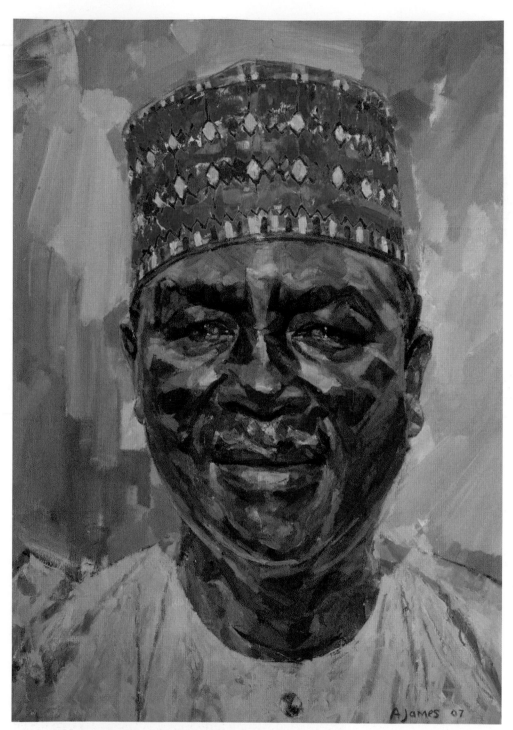

Andrew James, *General Yakubu Gowon*, 2008.

painting. I find this interesting, because for me it underlines the importance he places on the composition, and particularly the composition of colour.

Within a portrait by James there is often an abstracted use of colour. By this I mean that he is not intent on copying nature, but on finding relationships within his palette which are analogous to his observations. One might almost say that his use of colour in General Yakubu Gowon is themed. The frank, direct expression of the sitter is celebrated in the bold reds and greens,

which contribute an immediacy, an intensity to the General's engagement with the viewer. This is a particularly large painting, much more than life size, which further imposes on the viewer. The presence of the sitter is evoked by the pose, by the robust draughtsmanship and by the vibrancy of the colour.

This fabulous painting of *Ivy, Aged 99 Years* is, like the picture of General Yakubu Gowon, larger than life. The paint is applied with something of a frenzy, but the beautifully made nose is a testament to the painter's complete control. He allows paint to

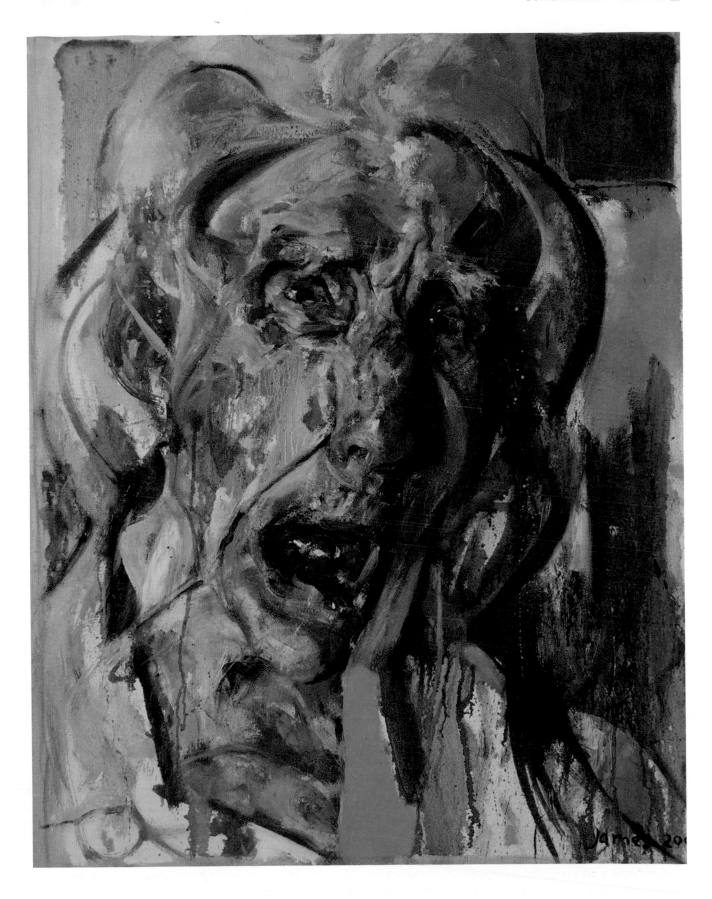

Andrew James, *Ivy, Aged 99 Years*, 2004.

run and surfaces to become layered and rubbed, all of which serve to evoke the accumulation of years and the accretion of experiences so urgently expressed in this portrait.

James Lloyd

James Lloyd likes to paint directly from life. He works straight onto the white primed linen. There is little or no preliminary drawing. His palette, which can be seen in the foreground of the self-portrait, consists of two or three blues, two yellows, two reds, Raw Sienna, Burnt Umber and Titanium White. There is no black. The surface tends to move across thick, layered pigment into smears of much leaner paint, polished almost back to the light of the primed linen.

These paintings represent the painter's unmediated response to his subject. Lloyd resists the temptation to refer, or indeed, to defer, to optical or mechanical aids. One has some sense that this painter is not interested in making paintings that are as 'real' as photographs; rather, he wants to make real paintings. The paintings lack minute microscopic observations, but they are dense and rich at a human scale. The pictures are founded in close and sustained observation. What lasts is the painter's feel-

ing for paint and the sense that the artist's intellect has been engaged with his subject. The painting is what is left when the painter puts down his brushes and the sitter departs. If the painting is the remnant, it is a remnant drenched in the presence of both painter and sitter. There is no contrivance, no submission to any authority, other than the painter himself. Whether painting a friend or working to a commission, there are just three primal ingredients – the painter, the painted and the painting. This may seem like a platitude, but contemporary portraiture is very often informed, in varying degrees and in different ways, by photography, so Lloyd is fairly unusual in his approach.

He paints directly and transparently, with the sitter seeing the painting as it progresses. Some painters prefer to resolve the painting completely before allowing the sitter sight of the finished object. Paintings have a habit of falling away from the painter, out of control. The painter will, in order to make a successful picture, have to go off in pursuit, repairing or rebuilding elements. That Lloyd is prepared to expose all this to his sitter is a testament to his integrity and professionalism.

In *Professor Drummond Bone*, the greys in this picture are reminiscent of James McNeill Whistler's painting, *Arrangement in Grey and Black Number 1*. There is a similar restraint, perhaps even more, but at the same time Lloyd's painting is that much more intimate. There is a considerably greater sense of presence. The crumpled sheen of the suit and the featureless wall evoke a cool, subdued day from which the warm face emerges, patient, shrewd and kindly. The sitter looks back at the painter. In this too, the comparison with the Whistler is interesting, in as much as Lloyd is clearly a presence in the room, looked up to by the sitter. Drummond Bone is less posed, there is more of a 'handheld' or '*cinéma vérité*' kind of perspective, more immediacy. The Whistler painting is detached. Whistler's mother may well be sitting in a characteristic pose, but Drummond Bone has definitely twined himself into his own, quite particular, shape.

The sitter's hair is like a black firework in *Phoebe Boswell*. The dark explosion framing the much warmer more delicate painting of the head. The crown of hair in this painting centres the head almost like an icon. The sitter looks away into the middle distance, seemingly conscious of the painter's gaze but undisturbed by it. There is attention in the regard. Again the cool grey allows the head to glow warm from the centre of the picture plane.

Lloyd's self-portraits often include quite elaborate concoctions of mirrors, paintings and studio paraphernalia. And they frequently depict a painter in motion. Paused, but set to move on. Lloyd talks about his reluctance to design a painting in too much detail. Much of the energy in his paintings derives, I feel, from this immediacy; he deals with problems as they arise. Some are undoubtedly foreseen, but others erupt from the act of painting itself. This is performance painting; live, energized, sudden.

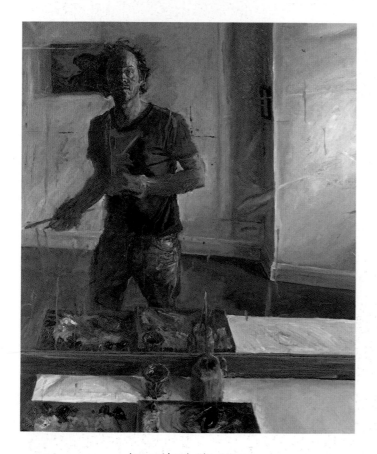

James Lloyd, *The Mirror*.

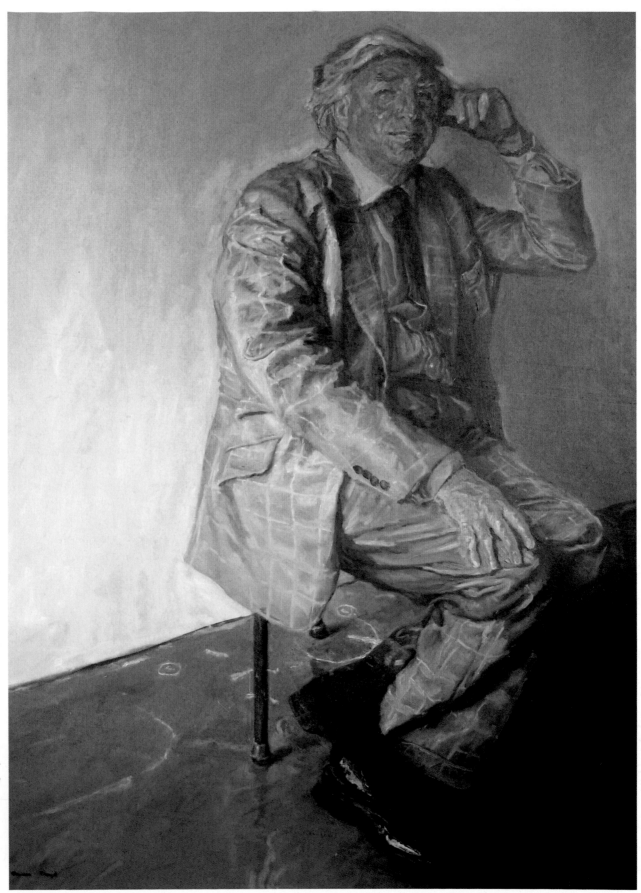

James Lloyd,
*Professor
Drummond
Bone.*

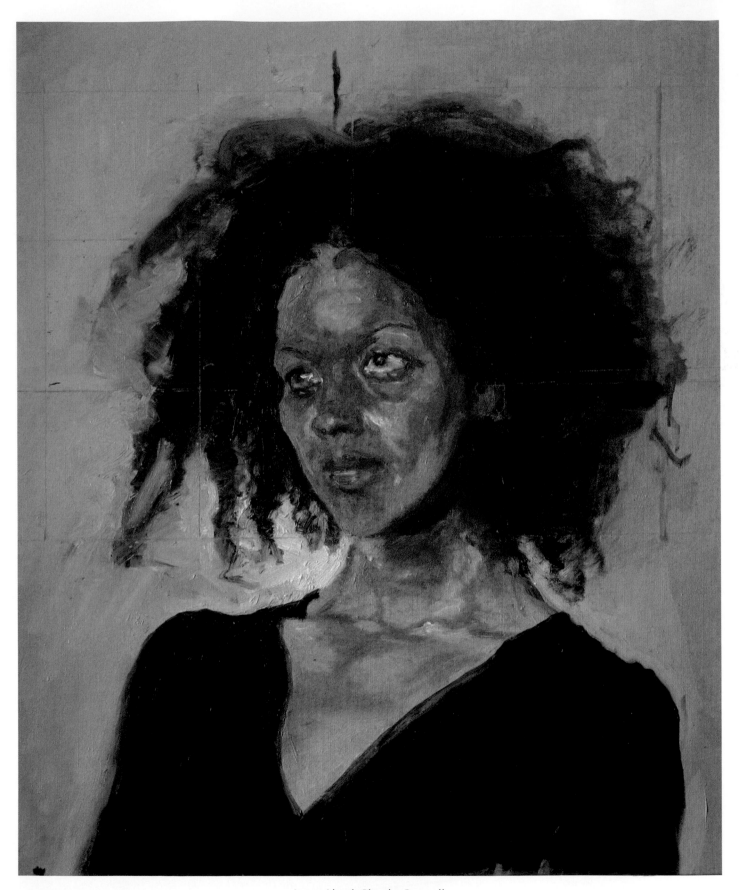

James Lloyd, *Phoebe Boswell*.

Summary

Different painters then approach portraiture in different ways. Is there a common thread? I'm not sure. I think they might all of them say that they wanted to make good paintings. I am less certain, however, that they would entirely agree about what constitutes 'good painting.' It might be difficult for them to find a meaningful definition to which they could all subscribe. They probably do all share an admiration of the work of some specific painters.

There are artists, not many, like Rembrandt whose work is more or less universally acknowledged. If they could agree on Rembrandt then shouldn't it be possible to analyse the work and identify the essential, common ingredients of 'good painting'? Let's suppose that they agreed that Rembrandt's *Self-Portrait Aged 51* (*see* page 59) is a great portrait, a 'good painting'. Would it be possible to construct a definition based on the qualities of this work? Probably not. Firstly because I suspect that each painter would identify a slightly different essential ingredient. Their selection would speak about their own concerns. Secondly, because the qualities which distinguish that painting would be somewhat different to the qualities of any other great portrait, Velázquez's *Innocent X*, for example.

Every serious painter is trying at some level to define 'good painting' for themselves. Sometimes their efforts are so compelling that their work becomes inextricably associated with other great work and it mutely enters a larger debate which takes place in our collective consciousness. In turn our perception of what 'good painting' might be is slightly altered.

If all this sounds somewhat vague, it is; but as Blaise Pascal wrote, 'do not hold this lack of clarity against us, since this is our profession.'

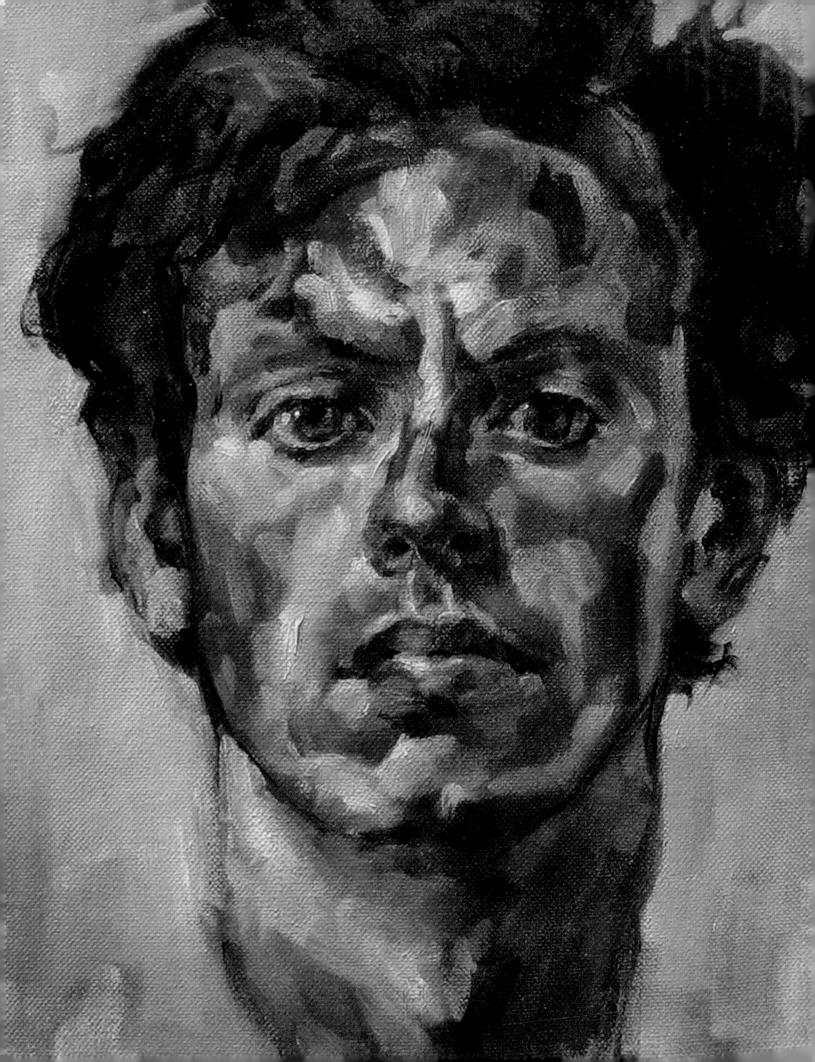

AFTERWORD

Contemporary painting is 'stepless'. 'Steplessness' is a phenomenon identified by James Elkins in his book *What Painting Is*. He uses the term to describe the absence of a technique, or an agreed process or sequence, which painters need to employ if they are to make viable work: 'In the twentieth century painting is a one-step process since the "steps" all blend into one another ...' It might seem at times in this book that I have suggested otherwise; the progressive stages in various chapters do suggest a stepped approach. I have, however, simply tried to illustrate the way I sometimes make painting, but, as for every other painter I know, that process is decidedly subject to change. Painters constantly review their practice. There is some intended order, but a painting rarely moves toward any kind of conclusion without improvisation. Today, painters concoct their own spells.

According to Elkins, painting has very much in common with alchemy. His exposition is layered, elaborate and persuasive. The alchemical recipe specific to a portrait would have to include the painter's sensitivity to his sitter. More than any material or technical consideration, the determination to keep looking would have to be the most important ingredient. It may be that Duncan is right when he tells Malcolm in Macbeth, 'There's no art / To find the mind's construction in the face.' The portrait painter persists, however, in the hope of disproving this assertion. Beyond a likeness, the portraitist wants to find exactly this 'art'. It is for the painter something akin to the philosopher's stone, something capable of revealing and fixing the precious from the base.

LEFT: *Thom.*

FURTHER READING

Arikha, Avigdor *On Depiction* (Bellew)

Barthes, Roland *Camera Lucida* (Vintage)

Bell, Julian *What is Painting: Representation and Modern Art* (Thames and Hudson)

Berger, John *The Shape of a Pocket* (Bloomsbury)

Braun, Emily (ed.) *Italian Art in the 20th Century* (Prestel)

Brown, Jonathan, and Garrido, Carmen *Velázquez – The Technique of Genius* (Yale University)

Elkins, James *What Painting Is* (Routledge)

Farthing, Stephen *An Intelligent Person's Guide to Modern Art* (Duckworth)

Gombrich, E. H. *The Story of Art* (Phaidon)

Hockney, David *Secret Knowledge* (Thames and Hudson)

Holroyd, Michael *Augustus John* (Heinemann)

Kitaj, R.B. *The Human Clay: An Exhibition Selected by R.B. Kitaj* (Arts Council of Great Britain)

Kosinski, Dorothy *The Artist and the Camera* (Yale University Press)

McKeever, Ian *In Praise of Painting* (University of Brighton)

The Notebooks of Leonardo da Vinci (Oxford University Press)

Pearce, Emma *Artists' Materials – Which, Why and How* (A & C Black)

Schneider, Norbert *The Art of the Portrait* (Taschen)

Sontag, Susan *On Photography* (Allen Lane)

Walker, Susan (ed.) *Ancient Faces* (Routledge)

Wiggins, Colin *Leon Kossoff – Drawing from Painting* (The National Gallery Co. Ltd.)

Visit the author's website www.anthonyconnolly.co.uk.

ACKNOWLEDGEMENTS

My thanks are due to Thomas Connolly and to Josephine Connolly for their indulgence, comments and criticism and to all my models for their forbearance.

Copyright Acknowledgements

INDEX